Watercolor Made Simple

with Claudia Nice

NORTH LIGHT BOOKS

CINCINNATI, OHIO

www.artistsnetwork.com

Claudia Nice is a native of the Pacific Northwest and a self-taught artist who developed her realistic art style by sketching from nature. She is a multi-media artist, but prefers pen, ink and watercolor when working in the field. Claudia has been an art consultant and instructor for Koh-I-Noor/Rapidograph and Grumbacher. She is also a certified teacher in the Winsor & Newton Col Art organization and represents the United States as a member of the Advisory Panel for the Society Of All Artists in Great Britain.

She travels internationally conducting workshops, seminars and demonstrations at schools, clubs, shops and trade shows. Claudia recently opened her own teaching studio, Brightwood Studio (www.brightwoodstudio.com), in the beautiful Cascade wilderness near Mt. Hood, Oregon. Her oils, watercolors and ink drawings can be found in private collections across the continent and internationally.

Claudia has authored seventeen successful art instruction books, including *Sketching Your Favorite Subjects in Pen & Ink, Creating Textures in Pen & Ink With Watercolor, Painting Nature in Pen & Ink With Watercolor, Painting Weathered Buildings in Pen, Ink & Watercolor, How to Keep a Sketchbook Journal,* and *Painting Country Gardens in Watercolor, Pen and Ink,* all of which were featured in the North Light Book Club.

When not involved with her art career, Claudia enjoys gardening, hiking, and horseback riding in the wilderness behind her home on Mt. Hood. She passes on her love of art and nature by acting as an advisor to several youth groups.

METRIC CONVERSION CHART

TO CONVERT	TO	MULTIPLY BY
Inches	Centimeters	2.54
Centimeters	Inches	0.4
Feet	Centimeters	30.5
Centimeters	Feet	0.03
Yards	Meters	0.9
Meters	Yards	1.1
Sq. Inches	Sq. Centimeters	6.45
Sq. Centimeters	Sq. Inches	0.16
Sq. Feet	Sq. Meters	0.09
Sq. Meters	Sq. Feet	10.8
Sq. Yards	Sq. Meters	0.8
Sq. Meters	Sq. Yards	1.2
Pounds	Kilograms	0.45
Kilograms	Pounds	2.2
Ounces	Grams	28.4
Grams	Ounces	0.04

Other fine North Light Books are available from your local bookstore, art supply store or direct from the publisher.

07 06 05 04 03 5 4 3 2 1

Library of Congress Cataloging-in-Publication Data
Nice, Claudia
 Watercolor made simple with Claudia Nice.
 p. cm.
 Includes index.
 ISBN 1-58180-251-X
 1. Watercolor painting--Technique. I. Title.
ND2420 .N4983 2003
751.42'2--dc21 2002032645

Editor: Christine Doyle
Designer: Joanna Detz
Page Layout Artist: Joni DeLuca
Production Coordinator: Kristen D. Heller

This book is dedicated to my dear husband, Jim, who is the encouraging whisper behind each brush stroke, and to the Master of all creation, whose work is my inspiration.

Table of Contents

I would like to introduce you to watercolor.

Don't be overwhelmed by the dollops of paint sitting in a neat row on the pristine palette, or the sheets of white, unmarked paper. Think of those paint dabs as playful children, full of fun and creativity. The paper is their playground. They instinctively know all the traditional games of hide and seek, climb and slide, and running races. The pigment children also know how to be very quiet and still if the game requires it. As much as the paint playmates love to frolic with abandon, their favorite game by far is "let's pretend." They have the unlimited imagination of childhood and can turn the white expanse of the playground into whatever is desired. Be it a storm-tossed sea, a sunlit meadow, a Victorian mansion or a bowl of strawberries, nothing is too difficult for these fanciful playactors. However, with the exuberance of youth ready to explode, these children need a little guidance. They need someone more mature to set boundaries and watch over them as they play. Someone who's not afraid to join in the spirit of the game. They need a mentor. This is the role the artist takes on.

The chapters of this book were developed to teach you how to become a skillful mentor, in the simplest way possible. Within these pages is the information you will need to properly prepare the pigment children for play, an explanation of the tools you will need to equip the playground and even some advice on transporting the children safely to the playing field. Best of all, I will show you how to direct the lively pigment playmates without spoiling their spontaneity. You and the watercolor can learn to become creative partners. As you relax and begin to know and understand the medium, you will find that it is both able and willing to do some of the creative process on its own. Watercolor truly is a unique and gifted child. So take it by the hand and walk unfettered by fear into a special world of artistic adventure.

Key Words to Know

Analogous colors
Hues that closely correspond to one another on the color wheel, like rose, red-violet, and violet.

Back run
A bloom pattern created when a bead of excess fluid is allowed to flow back into a settling wash.

Bead
A fluid gathering of excess moisture, which forms at the end of a stroke or at the bottom of a wet, tilted wash.

Bloom
A feathery, dark-edged design caused by any additional liquid flowing into a previously laid wash that has started to settle. Also called a flood mark, flower or puddling.

Blotting
Using an absorbent material to remove pigment from a fresh, moist wash or dry, painted surface that has been scrubbed.

Bruising
Dark marks created by dragging a hard, bluntly pointed object firmly through a freshly laid wash, thereby compressing the paper and creating a gathering of pigment in the depression.

Charging
The introduction of a wash liquid into an area of wet, freshly laid paint, thereby producing a spontaneous flowing together and blending of the two.

Complementary colors
Colors opposite each other on the color wheel.

Drybrushing
The use of a well-blotted, paint-filled brush over a dry, cold-press or rough paper surface to produce a textured pattern of partial paint coverage.

Flat wash
A smooth, controlled wash of uniform appearance.

Flow-altering technique
A process that disturbs the way the pigment settles in a wash, causing it to flow or relocate in a modified, textured manner.

Glazing
The application of a thin, transparent wash over a dry basecoat to create optical color change, alter intensity or develop shadows.

Graded wash
A smooth, controlled wash that varies gradually in value, color or both.

Granulation
The uneven disbursement of pigment particles over the paper surface to form a mottled appearance.

Hue
The color of paint—red, blue, green, etc. It may also refer to a paint made of artificial pigment (e.g. Vermilion Hue).

Impressed texture
A dark image or outline formed by the attraction of pigment to an object that has been pressed into a wet wash and secured there until the wash is dry.

Intensity or chroma
The purity of a color. Red is more intense (pure) than reddish brown.

Layering
The application of a heavy or opaque wash over a dry basecoat to create bold value changes, to silhouette shapes or to deepen shadow areas.

Lifting
The process of removing pigment from a previously painted area.

Masking
The use of frisket or artist tape to preserve white or light areas while darker washes are applied over them.

Optical color change
The illusion of a color mixture created by glazing a thin layer of paint over a dry underlying wash of a different hue.

Pigment
Tiny particles of colored matter.

Scraping
Dark-edged, light marks created when a blunt tool is dragged firmly through a stage two wash, thereby shoving moisture and pigment aside.

Scrubbing
Working a stiff, moist brush back and forth over an area of dry watercolor paint to loosen the pigment for removal.

Spatter
Flecks or small splotch marks that are flicked, flipped or flung onto the paper.

Splotch
An irregular spot created by dripping or flinging paint from a paintbrush.

Sponging
A texturing technique in which a sponge or other absorbent material is saturated with paint and pressed repeatedly to the paper.

Stain
A residue of color left on the paper after the main body of paint is lifted away.

Stamping
The surface of an object is painted and pressed against the paper to transfer an image or design.

Triad
A limited palette consisting of three colors that are spaced equally apart on the color wheel, such as orange, green and violet.

Value
The relative lightness or darkness of a color. Pink is a high (light) value, and deep maroon is a low (dark) value.

Variegated wash
A wash with a variance of texture.

Wash
A thin, fluid mix of paint and water applied to the paper.

Wash puddle
A small pool of water and paint pre-mixed on the palette. May also refer to a small painted wash area.

Wet-on-wet
The application of a wet liquid paint to a wet surface, creating a free-flow effect.

Getting Acquainted with the Tools

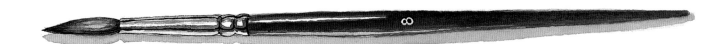

The tools in the still life on the opposite page are

just a few of the materials I've gathered to use in the creative process of watercolor painting. There is always a new brush to try out or another kitchen gadget that finds its way to my art studio as a nifty scraper, and the texturing tools are as widely varied as an artist's imagination. But don't be overwhelmed. Starting your watercolor tool collection is as simple as buying a brush... a round brush. Make it a no. 8 and the best quality you can afford. This is your most important tool. With this one brush you can do a watercolor painting. You will need at least three tubes of paint—a red, yellow and blue—a white dinner plate or plastic palette, a water jar and a sheet of watercolor paper. Oh yes, and grab some paper towels from the kitchen. With these eight items, you have the basic equipment and are ready to begin. Additional items can be added as you advance and find the need for them. This chapter explains the various watercolor painting materials you will encounter at the art store (or in your own cupboard), so you can make wise choices. Pass up the cheap, tacky tools and buy the good stuff, a little at a time. Quality paint, brushes and paper are the key to your enjoyment of the watercolor experience.

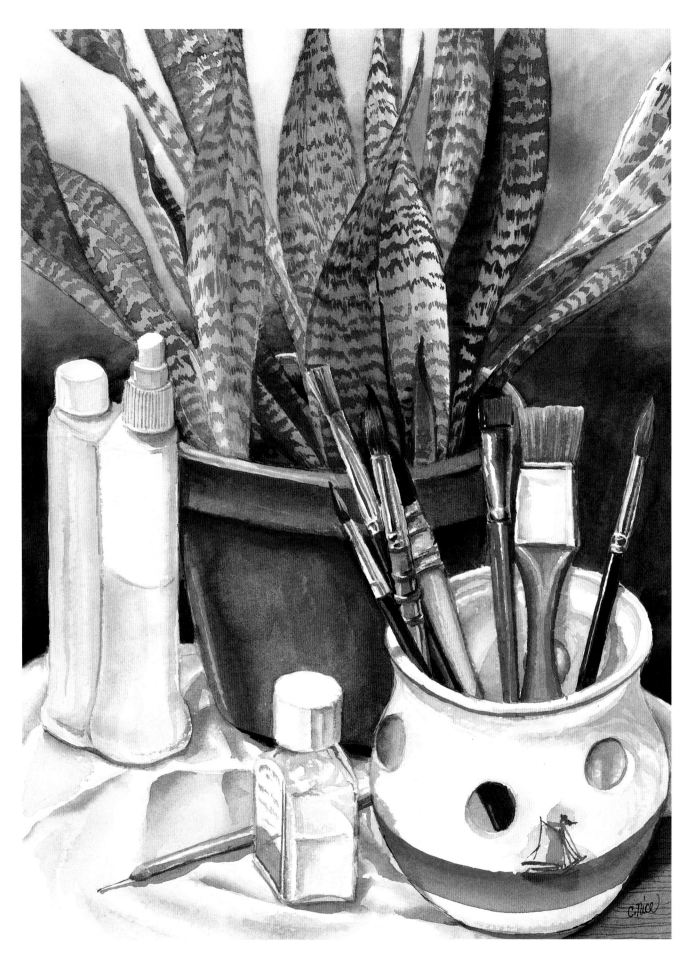

Watercolor Paper

Watercolor paper should be made of cotton fibers labeled 100% rag, with an acidity rating of pH-neutral (acid-free), to prevent it from turning yellow.

Texture –

Watercolor paper comes in three textures, rough, cold-press and hot-press.

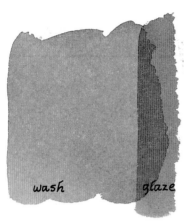 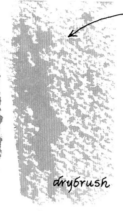

wash glaze drybrush

Rough paper has lots of hills and valleys on its surface which creates a wonderful dry-brush texture. It is very absorbent. Pigment settles well on its surface to create nice flat and graded washes. However lifting dried paint is difficult and fancy line work is tricky.

Cold-press or "Not" rough paper is weighted down during the drying process and has a smoother texture than rough paper. Its surface is textured enough for moderate dry-brushing effects and works well for various washes, glazing, lifting and flow-altering techniques. Cold-press paper was used for the paintings and examples in this book.

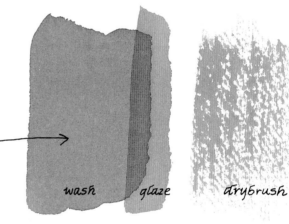

wash glaze drybrush

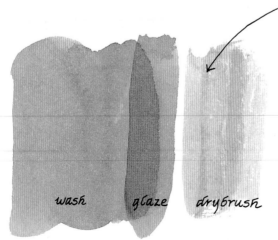

wash glaze drybrush

Hot-press paper is very smooth having been both pressed and heated during processing. It is preferred for hard-edged brush work and intricate detailing. The polished, less absorbent surface allows paint to run and mingle more freely, but smooth blends and glazes are difficult to achieve. Drybrushing creates streaks, but no paper texturing.

My favorite watercolor paper is Fabriano Uno (Savoir-Faire) followed closely by Winsor & Newton's Artists' Water Colour Paper, Arches, Lanaquarelle and Whatman. There are many other good brands I have yet to try!

Weight

Watercolor paper comes in different thicknesses. This is designated by how much a ream of a certain thickness of paper would weigh. The common weights are 70 to 90lbs, 140lbs and 300lbs. The heavier the paper, the more expensive it is.

Weight	Stability	Uses	Preparation
70-lb. (150gsm) to 90-lb. (190 gsm)	Too light for overall washes. Buckles badly and is easily torn!	Sketching, drybrush, light watercolor work.	Needs to be stretched before painting.
140-lb. (300 gsm)	With proper preparation will withstand complete surface coverage. Some buckling may occur.	Most watercolor techniques, including wet-on-wet, scraping and scrubbing.	Edges should be taped. Stretching for heavy wet-on-wet techniques advantageous.
300-lb. (640 gsm)	Handles saturation of entire paper surface well.	All watercolor techniques.	Edges need not be taped.

Blocks are paper tablets that have been gummed together on the edges to take the place of taping. They are ideal for outdoor field work. Keep in mind that the paper has not been pre-stretched and may ripple with heavy water applications. As it dries it will flatten out.

Presentation

Spiral tablets or tear off pads are economical and convenient. However, beware of those containing cheap student grade paper, which is very hard to work with. If it feels stiff, shiny, flimsy or has a mechanically produced texture, pass it up.

Whole sheets, 22" x 30", can be cut down into smaller pieces and are the choice of most professional artists.

For those who do not wish to mess with cutting, taping, stretching or ripply surfaces, choose a watercolor board. The watercolor paper is glued to an acid-free cardboard backing making it very stable even in wet-on-wet techniques.

Sizing

Sizing is the starchy substance added to paper to regulate its absorbency. Too little sizing and brush-strokes would feather out uncontrollably like painting on a paper towel. Too much sizing and the surface would actually repel the paint as if you were painting on wax paper.

Sizing may be decreased or redistributed if necessary by soaking the paper in cool water and gently blotting the surface with paper towels. (This can be done as part of the stretching process.) If you plan to work dry, the paper can simply be gently stroked with a moist sponge or a wet, flat brush, blotted and left to dry. (Redistributing the sizing is a good idea if you're planning to have large flat wash areas where a spot of concentrated sizing would show up and spoil the effect.)

Removing masking tape

Taping

If you're using 140 lb. paper or heavier and not planning to wet and work the whole surface at one time, taping the edges down is probably adequate preparation. Areas of the painting that become saturated with water may ripple as the paper stretches, but will regain its original flatness as it dries.

Taping provides a crisp white border around the edge of your painting that will provide you with a preview of how it will look matted and framed.

I use masking tape or drafting tape to fasten down the edges of dry watercolor paper. I place it overlapping the edge of the paper 1/4" and rub it to make sure it sticks securely. Make sure the paper is completely dry before removing the tape. Pull it off slowly, folded back sharply against itself. (See above illustration.)

Masonite backing board coated with a water proof finish.

Tape solidly all the way around.

Stretching the Paper

Watercolor paper less than 300 lbs. needs to be stretched if you want to eliminate wet paper ripples when using wet-on-wet techniques. Paper less than 140 lbs. will not hold up to such techniques, but will become more stable for light washes if stretched.

① Soak the paper (around 5 minutes) in a tub of cool water or brush it thoroughly on both sides with water until it's saturated. Avoid creasing the paper. Not only will creases weaken the paper, but may show up later in your painting as bruised lines.

An old wash tub works well for partial sheets.

② Place the paper carefully on a backing board and tilt it to drain off the excess water. Use the side of your hand to gently push the water to the edges of the paper and off the board. Lay the board flat and blot up remaining surface moisture with a pad of paper towels or damp sponge.

③ Fasten the edges of the paper to the board, all around the edges, using the brown packaging tape designed to adhere to a moist surface. If your backing board is a soft wood, staples or thumb-tacks could be used along with the tape for extra strength.

④ Let the paper dry completely in a flat position. It will shrink, becoming taut and ready for ripple-free painting.

The tape should straddle the paper, half on and half off.

staples

For strength, backing board needs to be at least 1/4" thick.

Brushes

Water color brushes come in two basic shapes: round and flat. However they can vary greatly in size, quality and brush fibers.

Natural hair brushes hold the best reservoir of water, allowing greater working time between "dips." The preferred choice is sable, the highest quality (and most expensive) being Kolinsky sable from Russia. Red sable is almost as good and more economical in price. If you're on a tight budget or not sure of your commitment to water color, a quality brush featuring a sable/synthetic blend or good synthetic fibers will do.

In choosing a brush, look for one with a neat, attractive brush head. There should be no loose or fly away hairs bent at odd angles. The ferrule should be firmly attached to the brush handle. To test a brush, rinse out the sizing in cool water. (Sizing is the stiff stuff that protects a new brush during shipping.) Shake out the excess water with a snap of the wrist. A good round brush should have a nicely pointed brush head. The hairs of a flat brush should flow together forming a straight, chiseled edge. Stroke the brush across a smooth surface. It should have a springy feel, the hairs bending in a gentle curve. Avoid brushes with stiff fibers or hairs that collapse limply at the ferrule. Don't be shy in asking to test a brush!

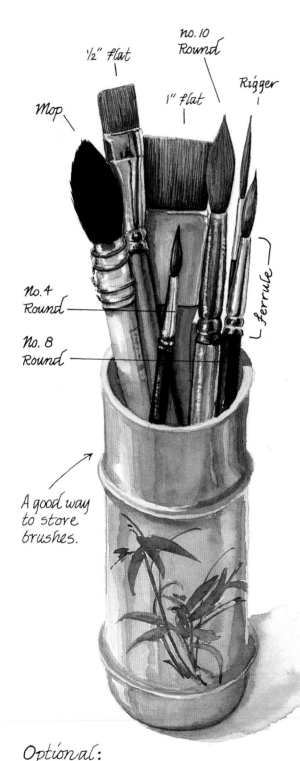

½" flat
no. 10 Round
1" flat
Rigger
Mop
ferrule
No. 4 Round
No. 8 Round

A good way to store brushes.

A basic watercolor brush collection should include the following:

. A no. 3 or 4 round - details, fine lines.
. A no. 6 or 8 round - small, irregular washes.
. A no. 10 or 12 round - large, irregular wash areas.
. ½" flat brush or Aquarelle - flat washes and variegated texturing. (A stroke lettering brush makes a nice alternative.)
. 1" flat brush - background washes.

Optional:

. ½" - 1" goat or squirrel hair mop - broad washes, softened edges.
. A no. 4 rigger or liner - fine, continuous lines.
. 2" flat (varnish brush) - background washes on full sheets.

Loading, Blotting and Cleaning the Brush

Fully loading the brush with water —

① Dip the brush in the water up to the ferrule.

② To avoid a drip, remove the drop of excess water at the brush tip by stroking it once against the inside rim of the water tub...

or touch the tip quickly and lightly against an absorbent surface.

Note: For a partially loaded brush, dip only the brush tip in the liquid very briefly.

Fully loading the brush with paint —

Ⓐ Dip the brush in the prepared paint and water mixture on the palette. Let the paint wick three-fourths of the way up toward the ferrule.

Ⓑ Remove the drop of excess paint by stroking it once against the paint tray rim or blotting the tip quickly and lightly against an absorbent surface.

To remove more liquid from the brush, stroke it several times against the tub or palette rim, or hold the side of the brush head against an absorbent surface and pull it along. To maintain the point of a round brush, use a rotating motion. Pressure and blotting time will determine how moist the brush remains.

Clean up —
Rinse out your brush head and ferrule by swishing it in clear water. Gently stroke it across the bottom of the water tub to loosen pigment residue. Change the rinse water often to prevent residue build up.

Before storing the brushes, remove excess moisture by blotting them thoroughly or shaking them with a snap of the wrist.

Never leave a brush soaking in water!

Hold the brush in a manner, that is comfortable for you.
Gripping the ferrule will give you tight control.
Holding the handle further back
will allow you greater freedom
of movement.

Stroke the brush with a
pulling action, so the
tip is the last part to
travel over the paper.

Brush
Strokes

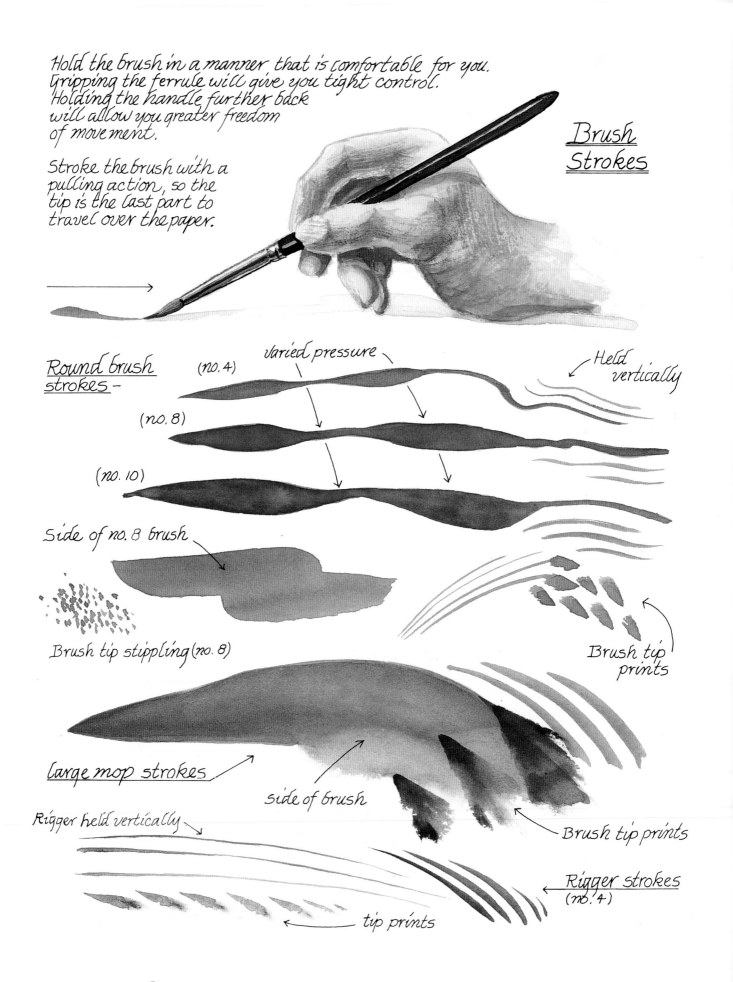

Round brush
strokes –

varied pressure

Held
vertically

(no. 4)

(no. 8)

(no. 10)

Side of no. 8 brush

Brush tip stippling (no. 8)

Brush tip
prints

large mop strokes

side of brush

Rigger held vertically

Brush tip prints

Rigger strokes
(no. 4)

tip prints

<u>flat brush strokes</u>

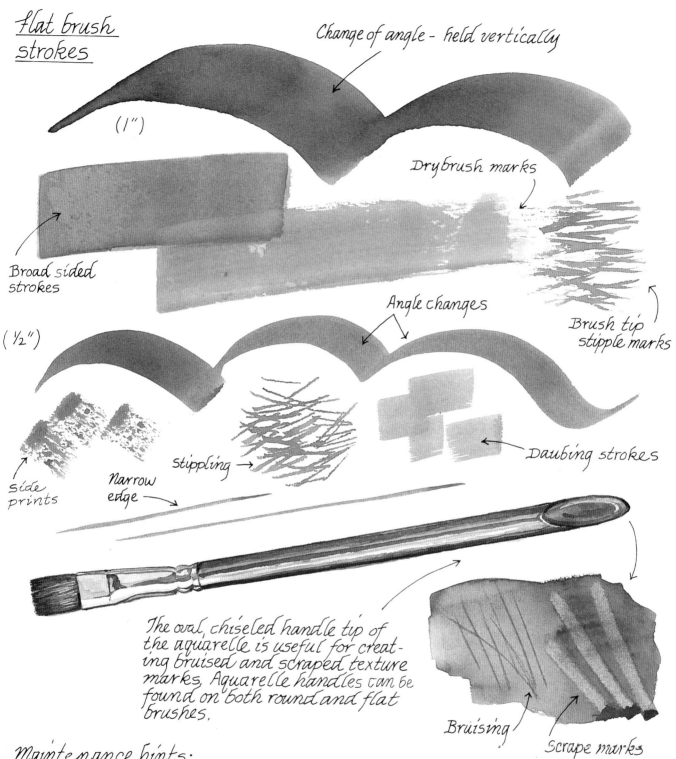

Change of angle - held vertically

(1")

Drybrush marks

Broad sided strokes

(½")

Angle changes

Brush tip stipple marks

side prints

Narrow edge

stippling

Daubing strokes

The oval, chiseled handle tip of the aquarelle is useful for creating bruised and scraped texture marks. Aquarelle handles can be found on both round and flat brushes.

Bruising

Scrape marks

Maintenance hints:

For long-time storage or travel, place your brushes in a reed, canvas or denim brush bag. That way they will be protected and still be able to breathe. Add a few cedar chips or moth balls for bug protection. If hairs become unruly, coat and shape them with starch or cream rinse. Leave them to reshape for a few hours, then rinse them out (Only for emergencies).

The Paint Palette

Watercolor palettes need to be made of a sturdy material such as enamel, hard plastic or porcelain. They need to be white to see the actual hues of the colors being mixed. White dinner plates or enamel butcher's trays work well for the actual color mixing process, but you will need an additional palette with wells to keep your base colors, squirted out from the tube, pure and secure.

Palettes with lids will help fend off pet hairs and other contaminants. Lids also help preserve the moistness of the paint from one painting session to the next. If your palette does not have a lid, remove excess moisture with a paper towel and wrap in plastic wrap for storage.

In my studio I use a large 12" x 16" rectangular plastic palette with a lid. The wells are on the outside, with an open mixing area in the middle.

I have several smaller palettes with hinged lids that I use for painting in the field. All the major art companies make field kits that include pan paints in a palette box, with brushes. However they are fairly expensive. Here is a pocket paint kit you can make yourself.

White lid forms a small mixing tray.

Cut a clear plastic butter tub lid into ¼" strips to form a grid. Hot glue it in the bottom of the tin.

Cut a sheet of plastic, with a pull-up tab on the side, to fit over the grid. When in place, the plastic barrier forms a separate storage compartment as well as a paint lid. I store a folded paper towel and a mini brush there.

2½" x 3" enamel candy tin.

Other Useful Tools

- **Water container:** I use the Masterson Fresh Water Rinse Well. With the press of a button, the dirty water empties into the bottom container and is filled with clean water from a plastic jar. But any water container—plastic butter tubs, collapsible water pots or glass jars—will do. Have two, one for clean "dipping" water and one for rinsing out the brush between colors. Change your rinse water often.
- **Water:** Use non-chlorinated water.
- **Spray bottle:** For moistening the paints on the palette or creating texture in your painting.
- **No. 2 pencil and a kneaded or white vinyl eraser.**
- **Paper towels and tissues:** For blotting, texturing and cleanup. (A folded paper towel, paint rag or damp sponge works well for blotting brushes.)
- **Non-permanent Art Masking Fluid (Winsor & Newton):** Use an old round brush or the Incredible Nib application tool to apply the masking fluid.
- **Rubber cement pick-up square:** For removing the masking fluid.
- **Brown packaging tape:** For paper stretching.
- **Artist tape, drafting tape or masking tape:** For taping down dry paper edges and masking.
- **Razor blades and blunt scrapers** (credit cards, mini chisel, an Aquarelle brush handle, palette knife, etc.).
- **Flat, waterproof backing board:** On which to mount your watercolor paper so it can be moved about and tilted. Masonite or Plexiglas works well. (Make sure it is at least ¼-inch [0.6cm] thick.)
- **Sponges:** Kitchen and natural sea sponge for texturing. Texturing additives such as table salt, rock salt, rubbing alcohol and sand.
- **Portable hair dryer:** To hasten drying time. Use this at a distance of 18 inches (45cm) or more from your work and with great caution, as drying the paint too rapidly can stop texturing action or change the flow of the paint.

razor

chisel

Incredible Nib tool

Watercolor Wisdom: Learning about the Paint

Watercolor is an ancient medium. The first paints

were earth pigments, such as ochre, mixed with water. As paint making became more developed, binders were added to help the pigments adhere to the painting surface. Today's watercolors consist of pigment, a binder (usually gum arabic), glycerins and sugars for moistness, a wetting agent (ox bile) for disbursement, a preservative and, of course, water. Sometimes special ingredients are added to make a certain blend unique. For instance, M. Graham watercolors contain honey for extra moistness. The formula differences between brands may result in color variations and differences in the way the paints feel and perform. Quality watercolors have a higher concentration of pigment and are processed through a three-roll mill a number of times, at a pressure low enough not to crush the pigment. The results are bright, rich colors with a smooth, even consistency. Economy paints are often thin, dull and inconsistent, with chunks of pigment showing up to spoil the washes. Working with such paint is not an encouraging experience. When selecting a brand, the artist should consider the advice of peers, but keep an open mind, be willing to experiment and decide for one's self. I started my art career using the Grumbacher brand and was very satisfied. Recently I have discovered the merits of Winsor & Newton and M. Graham, adding them with enthusiasm to my palette. There are many other good brands I have yet to try. Whatever brand you decide on, choose the artist grade or at least a high-quality student grade. It will cost more, but will be worth the difference in painting pleasure.

Tube and Pan Paints

<u>Tube colors</u> are premoistened and ready to work with. They accept water quickly and make strong, intense washes easily.

Paint should be moist (not overly runny) when squirted from the tube. →

With tube paint you have the advantage of having a source of pure, unpolluted color available when and where you want it. Paint from the tube can be squirted directly in the mixing area or in the wells of a palette to dry for later use.

Artists Water Colour Series 4A
Cadmium Lemon 0105 086
JAUNE de Cadmium Citron
Kadmiumgelb Zitron
Amarillo de Cadmio Limon
Giallo di cadmio limone

ARTISTS WATERCOLOR
SAP GREEN
M. GRAHAM & CO.

<u>Pan paints</u> consist of dry cakes of water-color made to fit into an enamel or plastic palette box. The pans of dry paint are activated by wetting the surface and stroking it with a brush to produce liquid color.

Pan paints are compact and the plastic palette boxes are light weight, making them ideal for field work. →

Pan watercolor box (reduced size).

It is important to learn to read paint labels. Markings vary somewhat between manufacturers, but should plainly state the color name, the pigment contained in the paint, the lightfast rating and any health warnings.

The lightfast rating states how well the paint will endure when exposed to light — whether or not it will fade. Acceptable ratings may be marked in the following ways— I or II, AA or A, ✳✳✳ or ✳✳. Avoid paints marked "fugitive."

Pay attention to health warnings. Watercolors are safe if used according to directions.

WINSOR & NEWTON
Artists' Water Color
Perylene Maroon
Marron de Pérène
Perylene Kastanienbraun
0101 507 Series 3A

Note:
To clean color-contaminated pan paints, brush them with water to liquify the top layer, then lift away the fouled paint with the brush or a paper towel.

Replacement pans and half pans are available. This is a half pan size (enlarged slightly).

The Character of Watercolor

Transparent colors (T)

Watercolor is considered a transparent medium. When applied in thin layers the light passes through and reveals the underlying washes.

Some colors are more transparent than others. Those known for their brilliance and clarity are labeled <u>Transparent</u>. Transparent colors have the most influence on washes that lie beneath them, creating distinct, optical color changes. They are useful in adding a light, airy feel to a painting and are preferred for glazing techniques. →

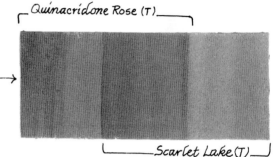

Quinacridone Rose (T)

Scarlet Lake (T)

Opaque colors (O)

Opaque colors contain denser, heavier pigment. Washes appear flatter. When opaque colors are glazed over an underlying wash, there is greater coverage and less apparent optical color change. These heavy hues are useful in toning down color mixtures and creating deep-valued shadows. →

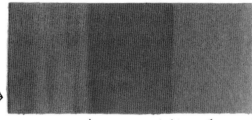

Cadmium Red, Lt. (O)

Light Red (O)

Note that where two opaque colors overlap there is more coverage and less distinct optical color change. ↓

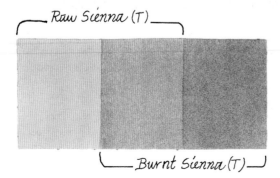

Raw Sienna (T)

Burnt Sienna (T)

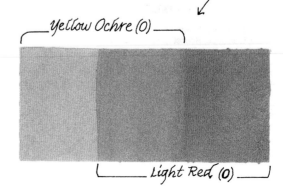

Yellow Ochre (O)

Light Red (O)

Granulating colors (G) *

Granulation is the mottled appearance that some washes take on when their pigment particles spread and settle unevenly to form tiny specks of more intense color. Some watercolor pigments are more prone to this than others. These Granulating colors are useful in creating natural-looking texture. The effect can be heightened if more than one granulating hue is mixed together and the wash is diluted with water to a thin consistency. Granulation is easier to achieve on rough paper than smooth.

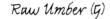
Raw Umber (G)

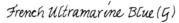
French Ultramarine Blue (G)

Rough paper

Raw Umber (G) French Ultramarine Blue (G)

Cold-Press

COMMON GRANULATING COLORS
Cadmium Red, Rose Madder Genuine, Cobalt Violet, Permanent Mauve, Cobalt Blue, French Ultramarine, Cerulean Blue, Cobalt Green, Viridian, Oxide of Chromium, Raw Sienna, Raw Umber, Ivory Black.

Non-Granulating hues for comparison.

Yellow Ochre Ultramarine Blue

* Based on Winsor & Newton Artist's Water Colours. Other brands may vary in their granulation qualities.

Staining colors (St)

Staining colors are powerful and cling to the paper tenaciously, leaving behind a residue of color when lifting techniques are used to remove paint.

COMMON STAINING COLORS
Cadmium Yellow, Winsor Lemon, Aureolin Yellow, Gamboge, Scarlet Lake, Cadmium Reds, Winsor Red, Permanent Carmine, Alizarin Crimson, Quinacridone Rose, Dioxazine Violet, Prussian Blue, Phthalocyanine Blue, Winsor Blues, Winsor Emerald, Winsor Greens, Oxide of Chromium, Hooker's Green, Sap Green, Venetian Red, Brown Madder, Perylene Maroon, Caput Mortuum Violet, Indigo, Payne's Gray, Neutral Tint.

Stain left behind when Sap Green wash was wiped away with a damp sponge.

Basic Color Concepts

The Primary Colors are red, yellow and blue. From these three colors, in their purest state, all other colors can be mixed, the exception being black and white. Red is the strongest primary hue. Color mixtures containing a noticeable amount of red or yellow are considered __warm__. Mixtures containing a lot of blue are considered __cool__.

The Secondary Colors are orange, violet and green. They are produced by mixing two primary colors together, and are found at a midpoint between those corresponding primary hues on the color wheel.

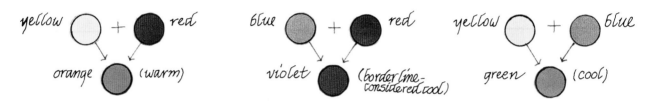

yellow + red → orange (warm)

blue + red → violet (border line - considered cool)

yellow + blue → green (cool)

Tertiary Colors are created by mixing a primary color with either of its two corresponding secondary colors. There are six groups of them spaced evenly around the color wheel.

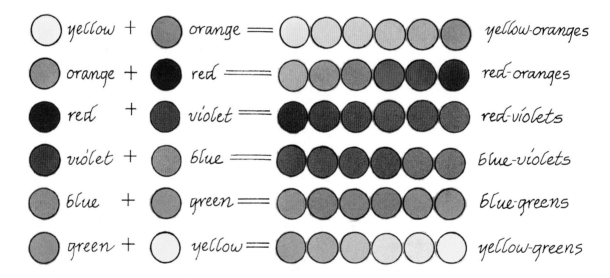

yellow + orange = yellow-oranges

orange + red = red-oranges

red + violet = red-violets

violet + blue = blue-violets

blue + green = blue-greens

green + yellow = yellow-greens

Grays are produced by mixing all three primary colors together in varied combinations. Those with a rich reddish or yellowish hue are called browns. The cleanest grays and browns are produced by combining __Complementary Colors__, which are those hues located opposite each other on the outer ring of the color wheel. As a greater amount of the complementary color is added to the mix, the tone becomes more muted, until neutral gray is reached. Some of the vast range of grays and browns are shown inside the color wheel on the opposite page.

Red-orange muted with blue-green results in sienna browns and gray tones.

base plus complement =

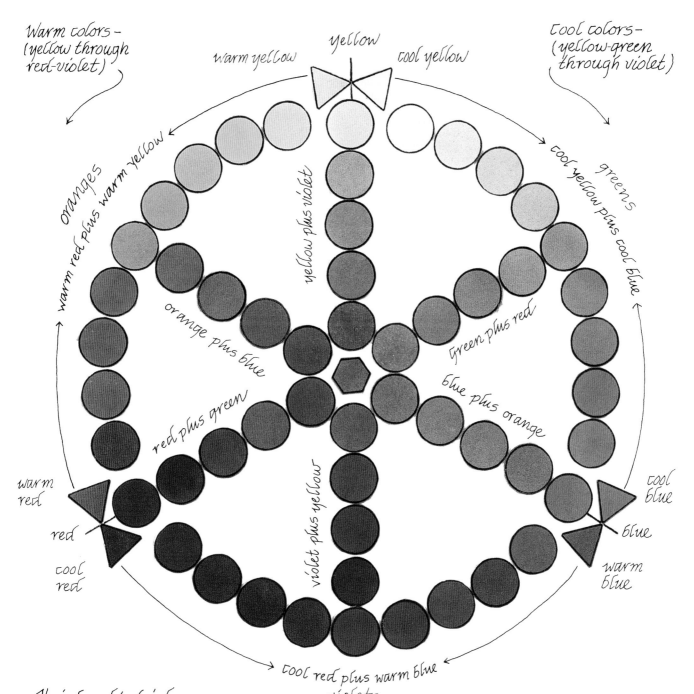

Warm colors–
(yellow through
red-violet)

Cool colors–
(yellow-green
through violet)

yellow

warm yellow

cool yellow

oranges

warm red plus warm yellow

yellow plus violet

greens

cool yellow plus cool blue

orange plus blue

Green plus red

red plus green

blue plus orange

warm
red

cool
blue

red

blue

cool
red

warm
blue

violet plus yellow

cool red plus warm blue
violets

It is hard to find an
absolutely pure primary red,
yellow and blue from which to mix vivid secondary and tertiary hues. For
instance, a paint labeled red may contain a hint of yellow. It will produce
bright oranges but because of the touch of yellow, any violets mixed from
it will be muted. The solution is to use six primary mixing colors, a warm
and cool representative for each primary hue. The color wheel above shows
when and how to use these six primary mixing colors effectively.

A medial red, yellow and blue can be produced by mixing the warm and
cool representative of each hue together.

Setting Up Your Palette

Start by selecting six primary mixing colors. Working with a limited palette will help you develop "color discernment." When you're able to recognize the subtle hues in the colors that surround you, you will be able to mix them on your palette.

Choose one color from each of the following categories. They will vary in transparency, cost and availability but all of them make good mixing primaries. I've underlined my personal favorites.

Warm Yellow
(leans toward orange)
- Cadmium Yellow
- Cadmium Yellow, Medium
- New Gamboge

Warm Red
(leans toward orange)
- Cadmium Red, Light
- Scarlet Lake
- Cadmium Scarlet

Warm Blue
(leans toward violet)
- French Ultramarine Blue
- Ultramarine Blue

Cool Yellow
(leans toward green)
- Azo Yellow (M. Graham)
- Aureolin Yellow
- Winsor Lemon
- Cadmium Lemon
- Winsor Yellow

Cool Red
(leans toward violet)
- Quinacridone Rose
- Permanent Rose
- Permanent Alizarin Crimson (W&N)
- Permanent Carmine
- Thalo Crimson (Grumbacher)

Cool Blue
(leans toward green)
- Pthalocyanine Blue (M. Graham)
- Winsor Blue (green shade)
- Thalo Blue (Grumbacher)

The secondary colors are used frequently in mixing. Therefore it is convenient to have a quantity of orange, green and violet available on the palette. It can either be mixed from the primaries or purchased in the tube.

Green
- Permanent Green (M. Graham)
- Winsor Green (yellow shade)

Orange
- Cadmium Orange
- Winsor Orange

Violet
- Dioxazine Purple
- Winsor Violet

The following key landscape colors are mixable, but they're used so often that they should be purchased eventually to save mixing time. Add to them your personal favorites.

 o Cobalt Blue – great base for mixing cool grays for sky and water.

 o Phthalocyanine Green, Winsor Green (Blue shade) or Viridian - vivid blue-green base color.

 o Hooker's Green - cool foliage hue.

 o Sap Green - warm foliage hue.

 o Yellow Ochre- opaque yellowish earth tone.

 o Raw Sienna — transparent yellowish earth tone.

} Choose one or both hues.

 o Burnt Sienna- reddish earth tone.

 o Burnt Umber- brown.

 o Raw Umber - neutral to slightly warm. (color varies greatly- optional).

 o Sepia - neutral earth tone.

 o Payne's Gray- cool, dark base for shadow mixtures.

Keep in mind that the color and characteristics of each hue can vary greatly from brand to brand.

The arrangement of your palette is important. Grouping the paints into color families will help you locate the hues quickly during the painting process. Once the order of your palette is established in your mind, avoid drastic changes. Leave space in each family group for new additions.

As you squirt the paint into the wells of the palette, spread it out rather flat so water can rest on the surface for activation.

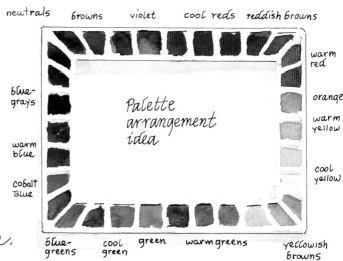

Palette arrangement idea

neutrals browns violet cool reds reddish browns

warm red
orange
warm yellow
cool yellow

blue-grays
warm blue
cobalt Blue

blue-greens cool green green warm greens yellowish browns

Mixing the Colors

If your base colors have hardened in the wells, begin by reactivating them with a drop of water placed on top of each paint blob or a light squirt from a spray mister bottle. To prevent color contamination, the actual mixing of hues takes place in a separate area of your palette.

① Fully load your brush in your clean water container, and press it against the bottom of the palette to release a puddle of water.

② Stroke the moist brush across the top of the activated pigment to load it with color.

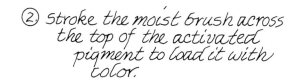

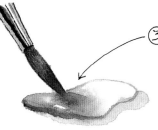

③ Gently mix the pigment into the water puddle to create a "wash of color." Release as much liquid as possible by stroking the brush against the side or bottom of the palette.

(To create heavier washes you may wish to start with pigment and add water.)

④ Rinse your brush out in the dirty water container. (If you want to preserve the paint still contained in the brush, simply set it aside and pick up a second, clean brush.)

⑤ Repeat steps one through four to create additional wash puddles for mixing.

warm blue cool red

violet

⑥ Bring the wash puddles together to form a third puddle of mixed color. Avoid over mixing. Traces of color variation can be exciting.

Too much red in this violet wash puddle!

Note: If a dominate color overwhelms the mix its sometimes easier to start over than to "tame" the offending hue.

Watercolor Made Simple With Claudia Nice

Experimenting With the Primary Colors

Try mixing the warm and cool primaries together in different combinations. The most dramatic possibilities are shown below. The results will vary somewhat according to the colors and brands you have chosen for your six primary mixing hues. Keep a record of your experiments for future reference.

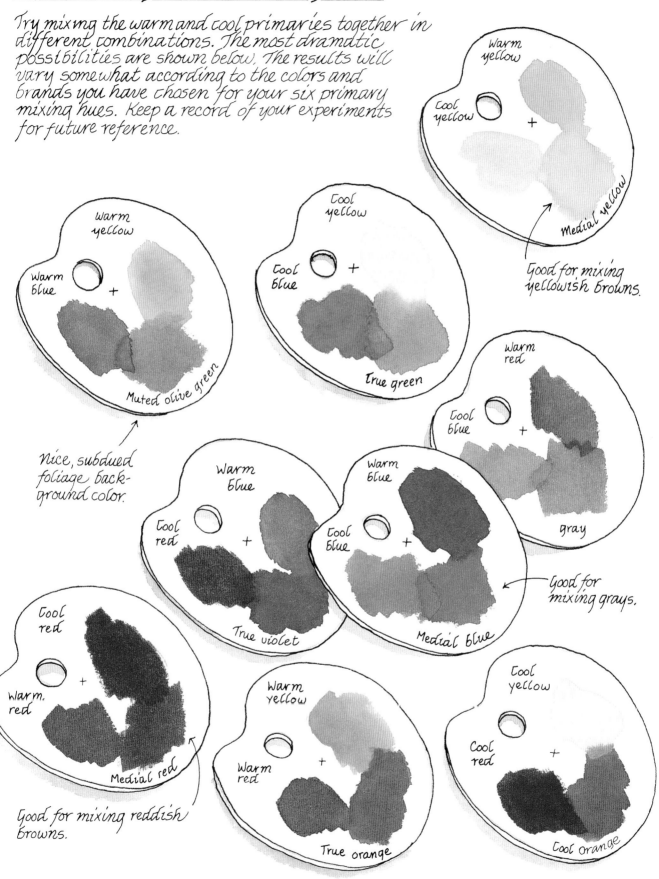

Warm yellow
Cool yellow
+
Medial yellow

Good for mixing yellowish browns.

Warm yellow
Warm blue
+
Muted olive green

Nice, subdued foliage background color.

Cool yellow
Cool blue
+
True green

Warm red
Cool blue
+
gray

Warm blue
Cool red
+
True violet

Warm blue
Cool blue
+
Medial blue

Good for mixing grays.

Cool red
Warm red
+
Medial red

Good for mixing reddish browns.

Warm yellow
Warm red
+
True orange

Cool yellow
Cool red
+
Cool orange

Mixing Browns and Warm Shadow Colors

Anytime you combine all three primaries together where red, orange or yellow dominates the mix, you will make a shade of brown or brown gray. However if you play with the mix too long, adding one color, then another, it will start to resemble your muddy rinse water.

Some over mixed, muddy browns.

Bright, high-intensity colors can always be darkened by adding Sepia, Payne's Gray, Black, etc., but the result is often dull and "off color." Shadow tones produced in this manner can make the object they're shading look dirty, corroded or, as in the case of the banana to the left, rotten.

Yellow mixed with Ivory Black for a shadow color. Yuk!

Yellow plus Payne's Gray

Yellow plus Sepia

These shadow mixtures are not much better.

The solution to creating perfect browns and shadow mixtures every time is to combine complementary colors (color wheel opposites). Start with the base color (yellow) and add the complement (violet) in tiny increments. The result will be natural-looking shadow hues, rich browns and clear neutral grays.

Yellow mixed with violet produces a range of rich, natural shading hues for a golden, ripe banana.

Practice by painting your own banana.

The chart below shows how easy it is to mix beautiful browns and brown-grays by combining complementary colors. The hexagons between the columns are common, pre-mixed browns from the tube. Note how close they come to the hand-mixed hues. (Tube colors that vary greatly by brand are shown in more than one location).

Complement added to base color equals shadow mixtures, browns and warm grays.

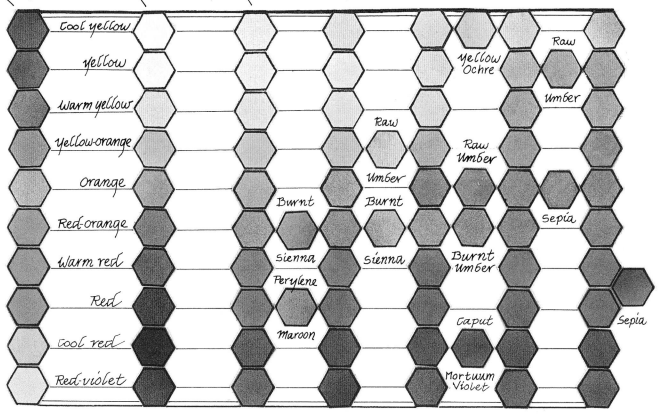

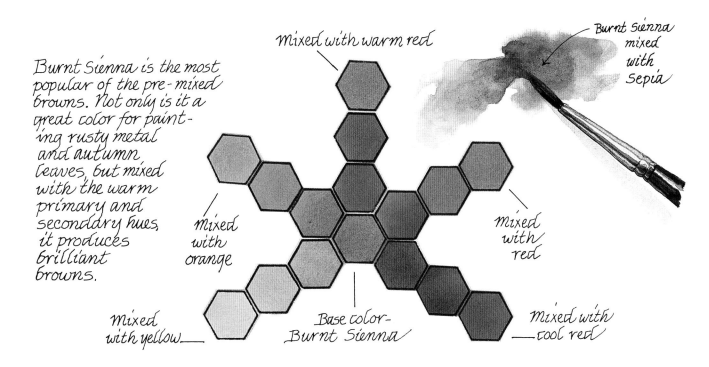

Burnt Sienna is the most popular of the pre-mixed browns. Not only is it a great color for painting rusty metal and autumn leaves, but mixed with the warm primary and secondary hues, it produces brilliant browns.

mixed with warm red

Burnt Sienna mixed with sepia

mixed with orange

mixed with red

mixed with yellow

Base color–Burnt Sienna

mixed with cool red

Mixing Leafy Greens and lively Blue-Grays

The chart below shows how to use complementary colors to mute vivid greens and blues into natural-looking hues with which to paint foliage, sky and water. The hexagons between the columns are common pre-mixed tube colors.

Complement added to base color equals shadow mixtures, muted tones and cool grays:

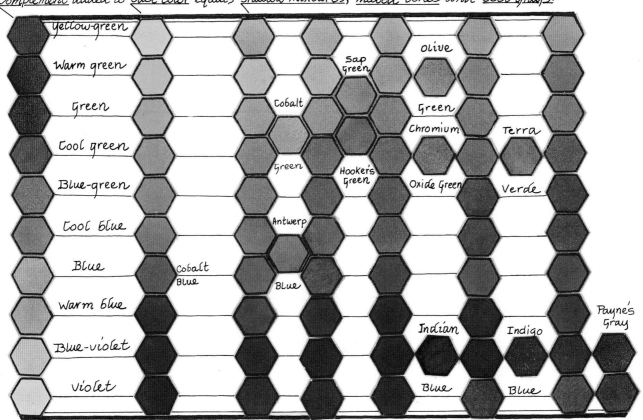

Sap Green, which is slightly muted and warmer than true green, makes a great base for mixing a wide range of natural-looking foliage hues.

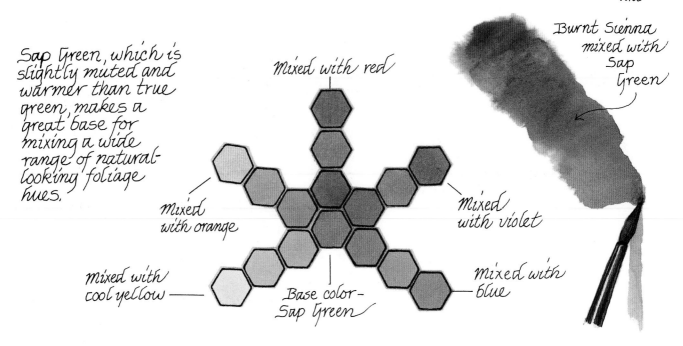

Mixed with red

Mixed with violet

Mixed with blue

Base color — Sap Green

mixed with cool yellow

Mixed with orange

Burnt Sienna mixed with Sap Green

Mixing Vibrant Darks

— Pre-mixed black from a tube can appear rather flat and lifeless, adding nothing to a painting but darkness.

Ivory Black

Black mixed from Sepia and Payne's Gray- dark and dull!

A better alternative to black is to mix your own darks, adding just enough color to the mix to keep them lively. By creating darks that are warm or cool, with a hint of color, you can use them to complement the hues used in the lighter areas of your painting. Complementary colors used side by side enhance and brighten each other.

The darks in this maple tree study were mixed from Permanent Alizarin Crimson and Phthalocyanine Green. Note how the deep blue-green makes the red-orange of the leaves stand out. ————————→

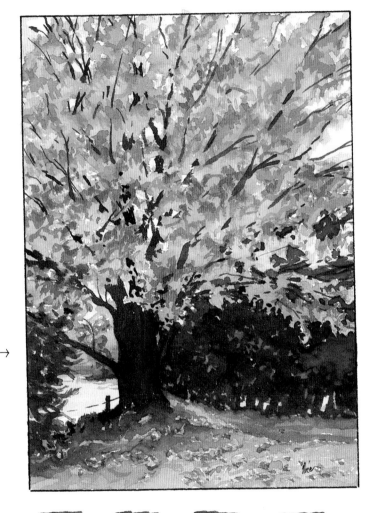

 + =

Alizarin Crimson

Phthalocyanine Green

Rich, neutral tone

Trunk color- more Alizarin Crimson

Background foliage- more Phthalo. Green

 — Cool darks

Payne's Gray

P. G. plus green

P. G. plus blue

P. G. plus violet

Some easy warm and cool dark mixtures using Payne's Gray or Sepia for a base.

 — Warm darks

Sepia

Sepia plus warm yellow

Sepia plus Warm red

Sepia plus cool red

Working With Color Triads

The limited palettes shown below are color triads. They consist of three hues which are spaced evenly apart around the color wheel. The hues in a triad harmonize and mix well together. Mixing any two of the triad colors together will produce a muted complementary color for the third.

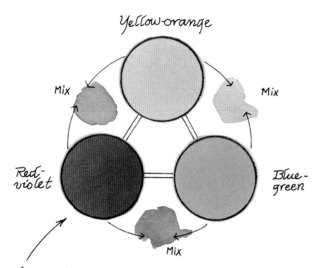

Yellow-orange

Mix Mix

Red-violet Blue-green

Mix

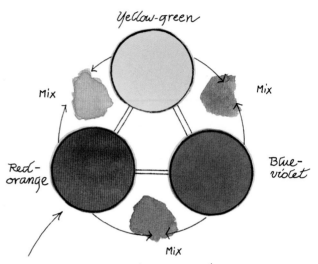

Yellow-green

Mix Mix

Red-orange Blue-violet

Mix

This triad of colors was used to paint the upper seascape (opposite page). I let yellow-orange dominate the scene, toning it down with a muted violet mixed from red-violet and blue-green. As a result, the mood of the painting is warm and sunny.

I used this triad to paint the seascape on the lower portion of the opposite page. (Note how earthy the mixed colors are. This triad is a good choice for painting landscapes.) By letting blue-violet dominate the seascape painting it took on a cool, wintery mood!

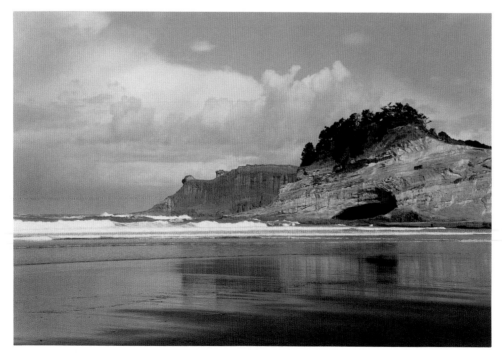

Practice project:

Sketch your own seascape from the photo to the left. Use the secondary triad colors of green, orange and violet to paint it. Pick one color to dominate the scene and see what mood you can create.

Watercolor Made Simple With Claudia Nice

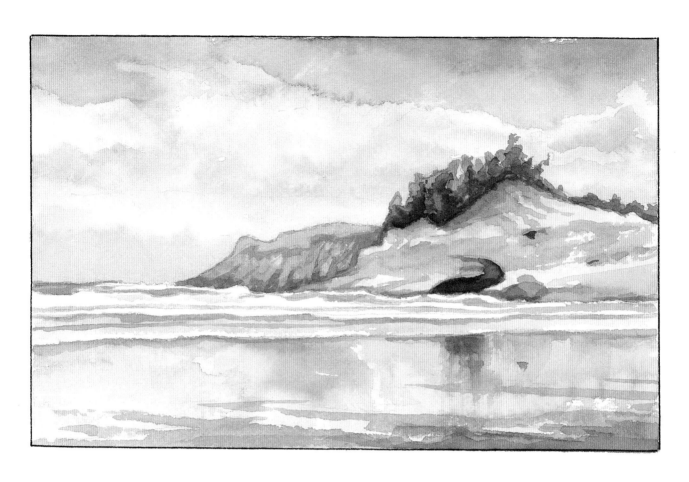

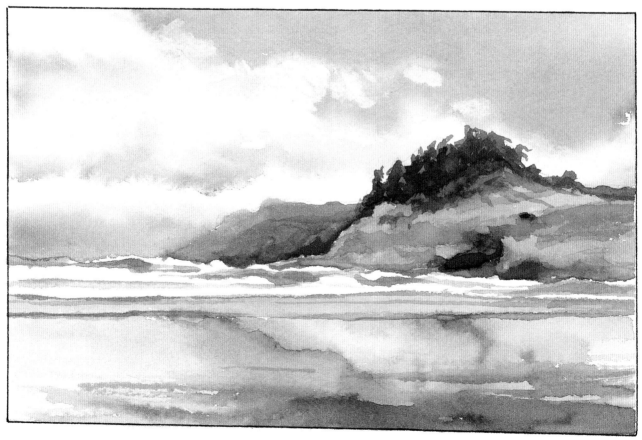

Watercolor Wisdom: Learning about the Paint

Working with Dry, Damp and Wet Surfaces

Watercolor paper is like a very thin, dry sponge.

When it comes into contact with liquid, it absorbs it, pulling the moisture into its fibers and swelling in the process. If the first liquid to touch the paper is a pigment-filled wash, then the thirsty paper will soak it right up, color and all. The paints won't have a chance to spread across the surface, but will filter downward, saturating the paper fibers. On the surface, the edge of the paint mark will remain hard and well defined. Lifting the color completely back out of the paper will be difficult.

If the first liquid to soak into the paper is an ample amount of plain water, the fibers will swell to their holding capacity and prevent any further liquid from being absorbed. A wash of paint, applied to the wet surface of the paper, will flow with uncontrolled abandon seeking the path of least resistance. Rivulets of color will form, traveling outward like a miniature flash flood, until the surge of liquid runs out. The paint, floating lightly on the moisture-laden surface, can be easily disturbed or blotted up. Tilting the surface may gather enough moisture to start it flowing again, forming new patterns. The free-flow effects of working wet-on-wet will continue until the surface dries enough to allow the paint to rest upon and bond to the paper.

There is a third paper moisture condition with which the artist can choose to work. It is the "damp" surface. The damp surface is where the paper is swelled internally with water but the surface is dry enough to have lost its wet sheen. A damp surface allows the artist to manipulate the paint readily over the surface of the paper in a controlled manner. The pigment flows easily, gliding on the moisture beneath. Drying time is extended, allowing more opportunity to create special effects.

In the painting *Sheep Pasture in Early Spring* (opposite page), all three surface moisture conditions were used. The entire painting was rendered using a no. 8 round brush, and a razor blade for dry scraping the stone fence.

Masking, the blocking of paint or water from touching the paper surface, is a convenient way to preserve whites and light value areas. Tips and techniques for accomplishing successful masking are discussed at the end of this chapter.

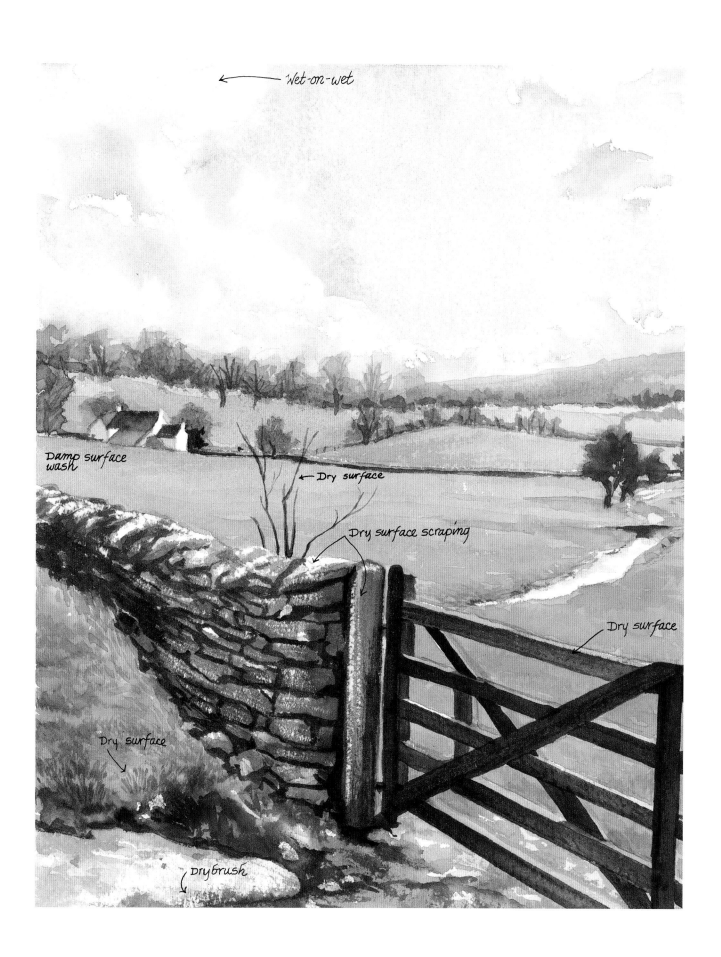

Wet-on-wet

Damp surface wash

Dry surface

Dry surface scraping

Dry surface

Dry surface

Drybrush

Dry Surface Techniques

Surface: The painting surface may be either dry paper or a dry wash of watercolor. It should feel dry, firm and warm (room temperature).

Advantages: The paint absorbs readily into the paper and dries quickly. It's good for large, textured underlying washes and the creation of small, smooth wash puddles. Brush strokes have hard, crisp edges, which are excellent for lines and detail work. Drybrushing produces great textural effects.

Disadvantages: Large wash areas are more likely to form streaks and brush overlap marks when applied to a dry surface. Paint penetrates deeply into dry paper making it difficult to lift dry pigment or soften hard edges.

Wash puddles

Small areas of color applied to a dry paper surface tend to settle with a flat, smooth appearance.

② Once the first paint puddle is completely dry, adjoining spots of color may be added. This green wash puddle, forming the decoy's head, is a mixture of blue-green and a touch of red-orange.

← Hard edges →

① This wash puddle will become the underlying wash for the body of a duck decoy. It is a mixture of Sepia and Yellow Ochre, thinned with lots of water. A no. 8 round brush was used to apply it.

A wash puddle should be laid down quickly using minimal strokes, and left alone to settle and dry.

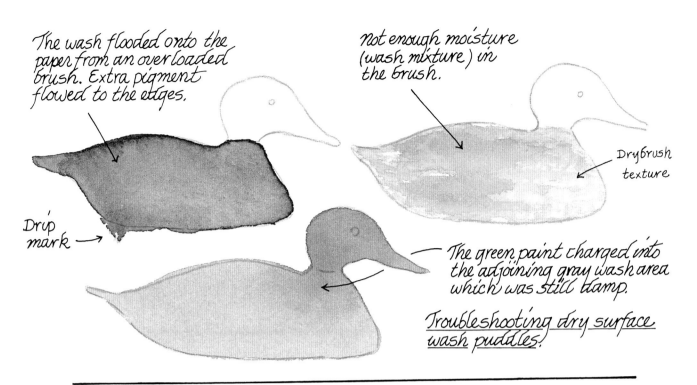

The wash flooded onto the paper from an overloaded brush. Extra pigment flowed to the edges.

Not enough moisture (wash mixture) in the brush.

Drybrush texture

Drip mark →

The green paint charged into the adjoining gray wash area which was still damp.

Troubleshooting dry surface wash puddles!

Lines and detail work

Brush strokes applied to a dry paper or paint surface hold their shape well. Here are some examples.

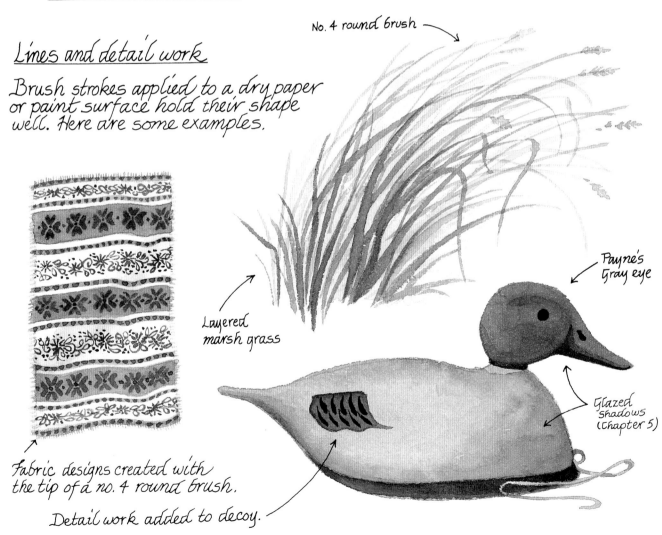

No. 4 round brush

Layered marsh grass

Payne's gray eye

Glazed shadows (Chapter 5)

Fabric designs created with the tip of a no. 4 round brush.

Detail work added to decoy.

Razor scraping

A single-edged razor blade can be used to add a highlight point, white line or an area of _light-valued_ texture to a _dry_, painted surface.

The object is to scrape away the dry paint leaving most of the paper beneath intact. Too much pressure or overworking will create a deep scar or hole.

Keep original paper cover for safe storage.

Using the corner of the blade will produce a white fleck or line.

Using the flat edge of the blade, lightly, will create a band of texture which has a worn, weathered look.

Note: Large white areas are hard to scrape out cleanly and are best left unpainted to start with.

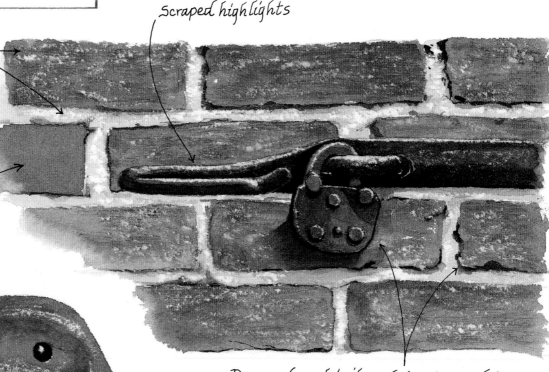

Scraped highlights

Scraped texturing

Rectangular wash puddle (Burnt Sienna and warm red mix).

Dry surface detail work (no. 4 round brush)

Scraping was used to add a worn, antique look to the decoy's head and a highlight dot to the eye. The neck ring was also scraped out.

<u>Splayed brush texturing</u> is a dry surface procedure in which the illusion of wood grain, hair and grass can be created using a flat brush. Here's how it's done.

① Select a flat or stroke brush appropriate to the size of the area to be textured. Fully load it with watercolor wash.

② Blot the lower edge of the brush lightly on a folded paper towel to remove the "swell" of excess moisture.

splayed flat brush

③ Use your fingers to gently spread apart (splay) the hairs at the lower edge of the brush. This will not harm the hairs if you are careful not to bend, pull or stretch them.

④ Draw the brush firmly, but gently toward you, making steady contact with the dry paper surface. The result should resemble woodgrain. The design will vary with each stroke according to the splay pattern and moisture content of the brush.

¼-inch stroke brush

Two strokes used side by side.

Splayed ¼-inch stroke brush over a dry wash. (multiple strokes).

Round brush detailing added.

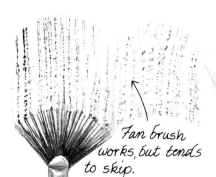

Fan brush works, but tends to skip.

Splayed brush grass.

Fur...

or short, dry grass.

Drybrush

Drybrushing is a dry surface technique which utilizes a blotted brush and the texture of the paper to produce a rough pattern of partial paint coverage. The brush deposits the paint on the raised portions of the paper and the valleys are left white. The rougher the paper texture, the more pronounced the pattern becomes. The steps are shown below.

single stroke

Heavily worked area.

The wash puddle should be a slightly heavier consistency for drybrushing.

① The brush is filled with liquid color. A flat brush is usually used for drybrushing because it has better coverage and is firmer.

② Blot the brush lightly on a folded paper towel (both sides), so it remains moist, not wet.

③ Stroke the brush firmly across the paper. It should look like this.

Some common drybrush problems

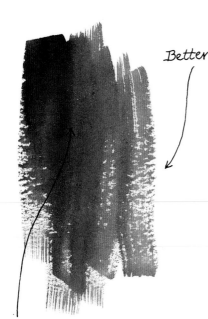

Better

The brush was too wet.

Overworked! The brush was "scrubbed" back and forth.

Brush was too dry.

O.K. if only a hint of texture is desired.

Damp area on paper.

Watercolor Made Simple with Claudia Nice

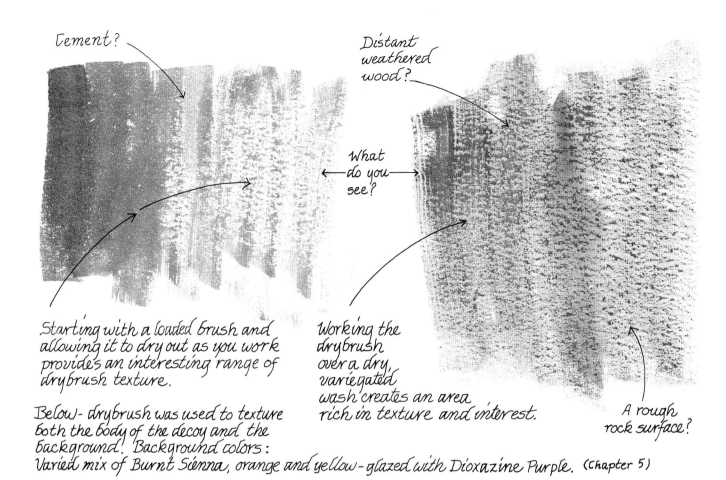

Cement?

Distant
weathered
wood?

What
do you
see?

A rough
rock surface?

Starting with a loaded brush and allowing it to dry out as you work provides an interesting range of drybrush texture.

Working the drybrush over a dry, variegated wash creates an area rich in texture and interest.

Below- drybrush was used to texture both the body of the decoy and the background. Background colors:
Varied mix of Burnt Sienna, orange and yellow- glazed with Dioxazine Purple. (Chapter 5)

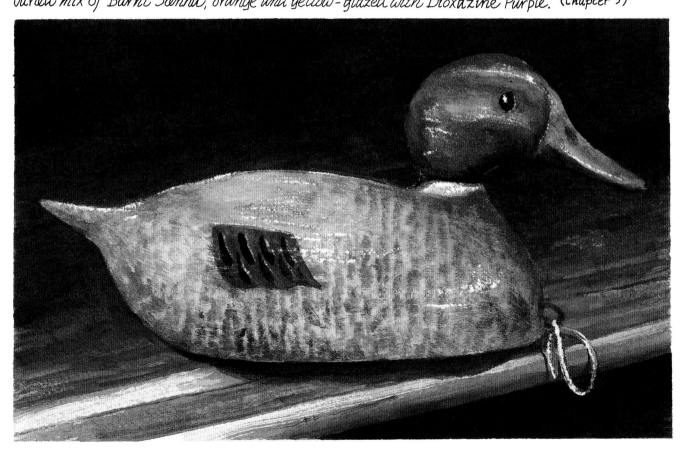

Damp Surface Techniques

Edges may fray or feather out.

Surface: A damp surface can be created by soaking, sponging or brushing the paper liberally with water, allowing it to swell internally. Wait one-half minute or more, then blot away the wet surface sheen with a paper towel. It should feel cool and damp to the touch.

Advantages: The paint glides readily over the moisture-filled paper making it easier to lay down large, smooth washes and create blends of color or value. Drying time is lengthened. It is the ideal surface condition for creating flow-altering textural effects.

Disadvantages: Longer drying time if you're in a hurry.

Simple blended color changes

Colors can be blended together readily on a damp surface because the pigment stays fluid longer and is easier to move over the moisture-filled paper beneath.

① Begin by laying down a few strokes of a single color wash on a damp surface.

② Wipe the excess color from the brush on a rag or paper towel.

③ Dip the brush in the new color.

④ Blot it.

⑤ Continue painting, overlapping the last stroke laid down of the previous color.

A spontaneous blend of color should appear where the two colors overlap.

Special effects

Flow-altering techniques (processes that change the way that the pigment settles in a drying wash) are more effective when applied to a damp surface wash. Some examples are shown below. These techniques are discussed in greater detail in chapter seven.

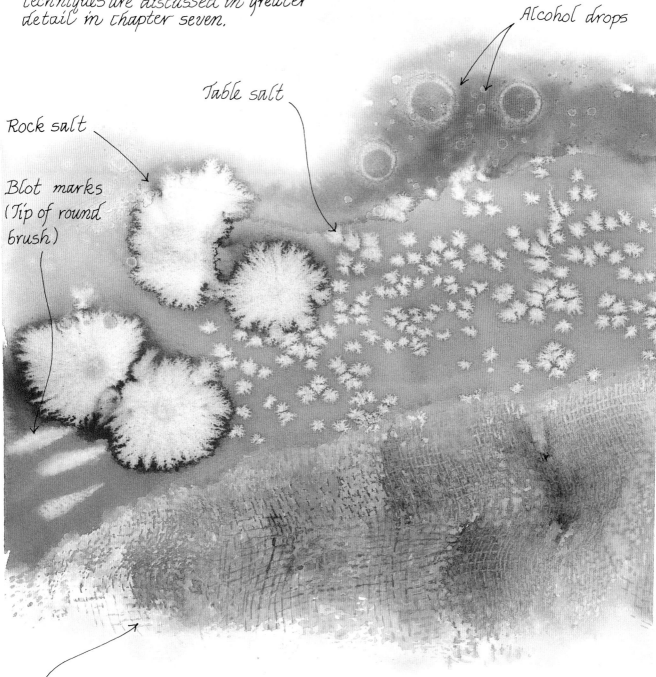

Alcohol drops

Table salt

Rock salt

Blot marks
(Tip of round brush)

Impressed texture (Gauze pressed into a damp surface wash and left until dry.)

Edges

A variety of edges are possible when working on a damp surface.

Hard, crisp edge.
(Paper surface slightly damp - well blotted.)

Frayed, feathery edge.
(Paper surface very damp, just shy of having a wet sheen.)

Soft edge.
(Blended manually with a brush.)

Hard edges denote solid perimeters or abrupt angle changes with-in an object.

Soft, blended edges on the surface of a hard object suggest rounded contours.

Soft or feathery edges denote shapes that have indistinct per-imeters due to their texture, dis-tance, lighting, visi-bility or the fact that they are in motion.

Creating a blended edge

(A) Lay down a small wash area on a damp surface.

Common problems -

Backrun, too much water in the brush.

(B) Using a clean, moist brush, stroke along the edge of the wet wash area to lift and remove some of the paint. The brush must be rinsed out and blotted every three or four strokes!

Paint spread, brush not cleaned out often enough.

In this portrait of my grandaughter Mikaela Regan, I applied the pale flesh tone wash to a damp surface and softened the contours of the face using the brush-blending technique explained on the opposite page. Subsequent layers were glazed on (see chapter five) to deepen the shadows, but brush blending was still part of the process.

Basic flesh tone mix —
Base: Burnt Sienna
Add a bit of blush with a little Quinacridone Rose.
Add a hint of Sap Green to tone down the mixture. More green in the mix will create shadow tones.

For darker skin, experiment with a mix of Burnt Sienna, red-violet and yellow-green.

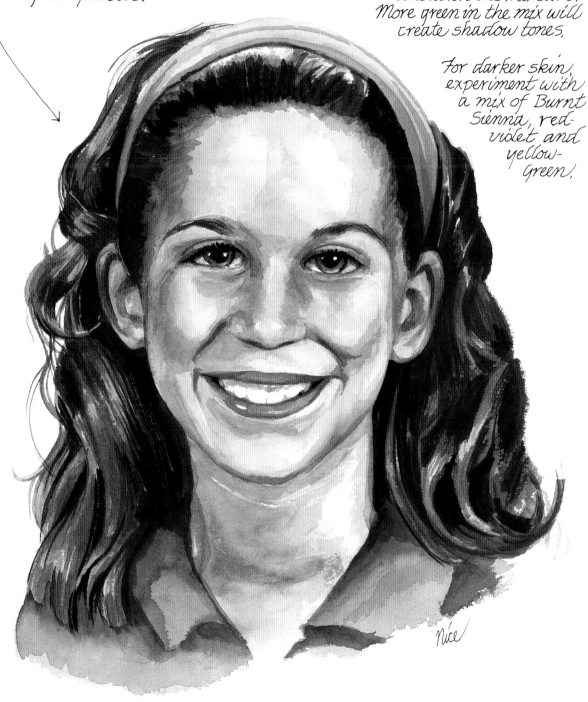

Nice

<u>Wet Surface</u>
<u>Techniques</u>

Surface: The paper is wet,
with a visible, glossy sheen.
However, it should not have
standing puddles of water any-
where on the surface.

Advantages: The paint moves freely over the
glossy wetness like a skater on ice. It spreads
spontaneously following the path of least resistance
until the flow of liquid pigment is dispersed. The
result is a softly patterned area with feathery, flowing
edges and subtle changes of value and color. This technique
is great for creating gently textured backgrounds, billowy skies,
fluffy effects and the indistinct appearance of distant shapes.
The element of surprise adds a touch of adventure to the process.

Disadvantages: Once the paint leaves the brush there is little control,
other than tilting the paper to establish flow direction or blotting
up the moisture to stop the flow. Wet surface washes take a long
time to dry. They should not be blasted with hair driers as the move-
ment of the paint will be changed, slowed or stopped.

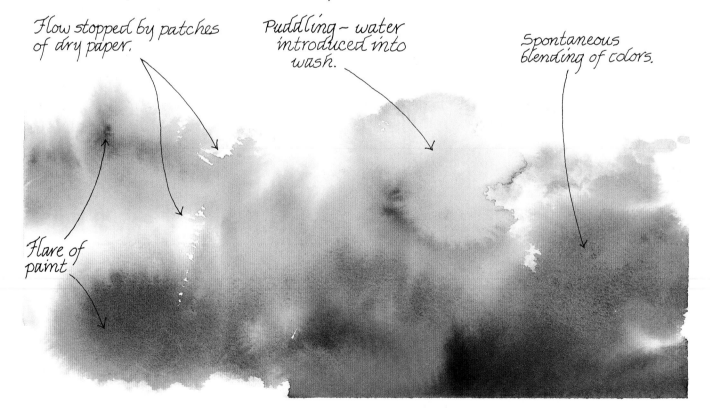

Flow stopped by patches
of dry paper.

Puddling – water
introduced into
wash.

Spontaneous
blending of colors.

Flare of
paint

<u>Wet-on-wet</u> is art jargon referring to the application of a wet liquid paint (wash) to a wet surface.

For the best result the brush should be fully loaded and blotted just enough to remove the drip from the tip.

Caution: Over-stroking the paint will work it down into the paper where it can no longer flow freely!

Shown below and on the opposite page are some common wet-on-wet effects and what caused them to occur. See if you can duplicate them on scrap watercolor paper.

Directional flow

The paper was tilted down-ward in the direction of the arrow.

Small flares-
The tip of a no. 4 round brush was used to touch the paint to the paper.

Water drops dripped into a wet-on-wet wash which had begun to settle.

This is what happens when a brush stroke passes through a puddle of standing water. The pigment is scattered widely leaving an area of lighter value. The effect is unpredictable. It may produce a light-valued flare as seen above, but more often than not the result is a dull smudge, which is seldom desirable.

Creating wet-on-wet cumulus clouds

① Start with a cloud formation in mind. A simple pencil sketch will help clarify it. (Cumulus clouds have fairly flat bottoms and fluffy, heaped-up tops.)

② Prepare the paper. Soak it, sponge it or brush it thoroughly with water until it is saturated. Tape down the paper edges to a backing board or table, and brush away any standing puddles of water with the side of your hand.

③ Activate the paint on your palette with a drop or two of water. Make two wash puddles...

Summer sky blue— a mixture of Ultramarine Blue and Phthalocyanine Blue (blue-green).

Payne's Gray— a medium-dark wash.

④ Brush the blue mix horizontally across the sky areas using a ½-inch flat brush. Providing that the paper still has a wet sheen, the paint will flow and feather along the edges.

⑤ While the paper is still moist, brush Payne's Gray across the shaded parts of the cloud. The tone will lighten as the paint flows and spreads.

⑥ As soon as the blue sky wash stops flowing and the pigment settles downward against the paper, but is still moist, brush a little water along the inside perimeter of the white cloud formation. The water will bloom outward, pushing into the blue sky to create billowy cloud edges.

Water drops were sprinkled into the moist gray paint here.

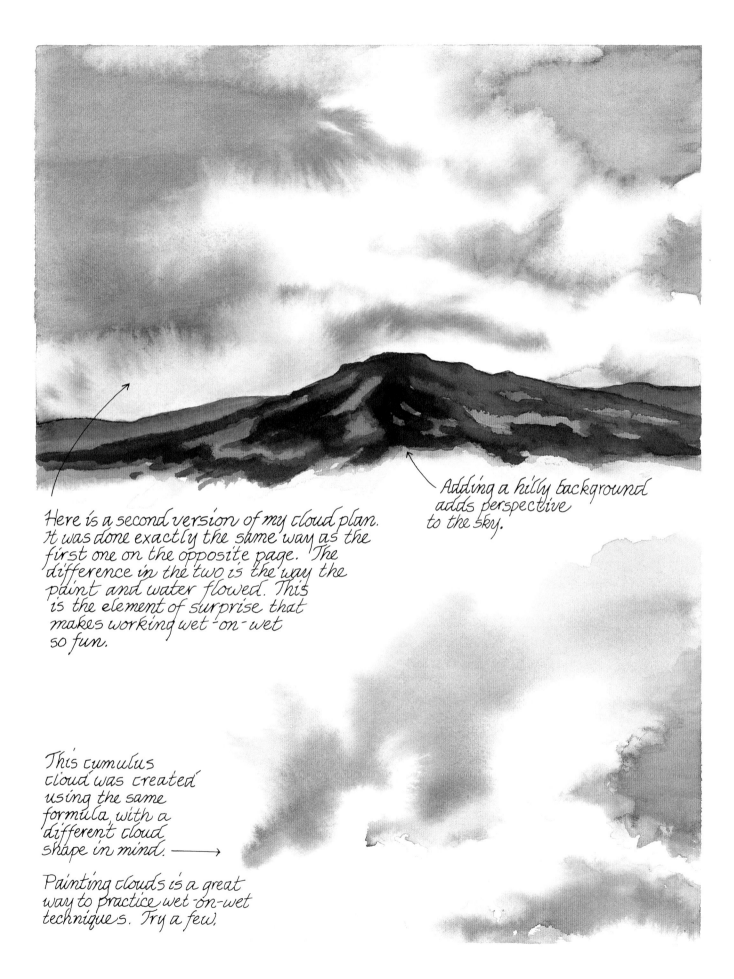

Adding a hilly background
adds perspective
to the sky.

Here is a second version of my cloud plan.
It was done exactly the same way as the
first one on the opposite page. The
difference in the two is the way the
paint and water flowed. This
is the element of surprise that
makes working wet-on-wet
so fun.

This cumulus
cloud was created
using the same
formula, with a
different cloud
shape in mind. ──→

Painting clouds is a great
way to practice wet-on-wet
techniques. Try a few.

Masking

There will be times when you desire to have many white or lighter-valued shapes within a large area of darker color. The easiest way to accomplish this is to mask out or place a protective shield over the white or light-valued shapes, and proceed to paint the background washes as if the lighter areas weren't there.

Masking is a dry surface technique. The various masking treatments are applied either to a dry paper surface or over a dry wash. The mask is left in place until all the washes to be applied over it are painted on and are <u>completely dry</u>.

The patch of star-lit sky (left) was created using masking fluid, spattered on with an old tooth brush. The larger stars were dotted on with a pointed brush handle.

Advantages: Masking allows the opportunity to preserve numerous white or light-valued shapes without painting around them. Thus background washes can be applied freely and quickly. Most dry surface, damp surface and wet-on-wet painting techniques work well in conjunction with masking.

Disadvantages: Masking always produces hard-edged shapes. These hard edges are difficult to soften if that is the desired effect. If great care is not taken, masking fluid or tape can pull up paint or tear the paper during removal.

Masking with tape — Use drafting tape, artist tape or masking tape (least desirable).

① Cut or tear the tape into the desired shapes and rub them securely into place.

② Paint background.

③ Let wash dry and carefully remove tape.

④ Finish foreground.

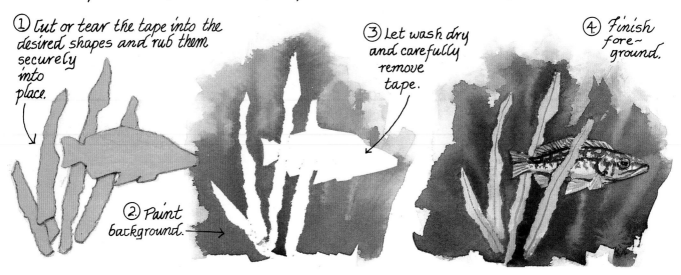

Using masking fluid

Masking fluid is especially useful for masking out narrow lines, finely detailed areas or numerous small shapes. Almost anything that will transfer the masking fluid to the paper can be used for application — toothpick, feather quill, dip pen, old round brush, etc. Keep in mind that the fluid turns gummy rather quickly and will ruin brushes, so choose one *you're* not attached to. I have found The Incredible Nib® a very useful application tool (pictured in chapter one, last page).

The foamy white out-line of the seafoam bubbles were blocked out using masking fluid applied with both a dip pen and the Incredible Nib.

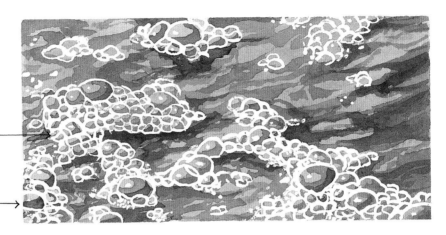

The edges were masked with artist tape.

Rinse and relather the brush often.

Helpful hints~

• If *you're* using a brush to apply the masking fluid, work up a lather on a bar of soap and fill the brush hairs with it before dipping the tip in the masking liquid. It will protect the brush fibers somewhat.

• If the masking fluid is too thick to flow nicely, thin it with a drop or two of water.

• Don't leave masking fluid on the work surface for extended periods of time. After a day or two it will be harder to remove.

• The painted surface must be completely dry before attempting to remove the masking fluid. Failure to wait may result in smeared paint, smudged white areas and patches of torn paper.

• Use a rubber cement pick-up block or a piece of masking tape wrapped around your finger, sticky side out, to dab away the used masking fluid from the paper. Avoid rubbing it away with your finger—the friction sometimes causes heavy paint layers to smear.

Oops! A paint smear.

Step-by-step Masking Project

Use this 5 x 7 inch alder tree design or sketch out a similar one of your own creation. Pencil it lightly onto a piece of 140 lb. coldpress watercolor paper. Tape the edges down to a table top or backing board.

Palette: Payne's Gray
Burnt Sienna
Cadmium Yellow
Sap Green
Sepia

① Use masking fluid and a small * round brush to mask out the areas drawn in red.

Let the fluid dry completely.

* The incredible Nib also works well for this.

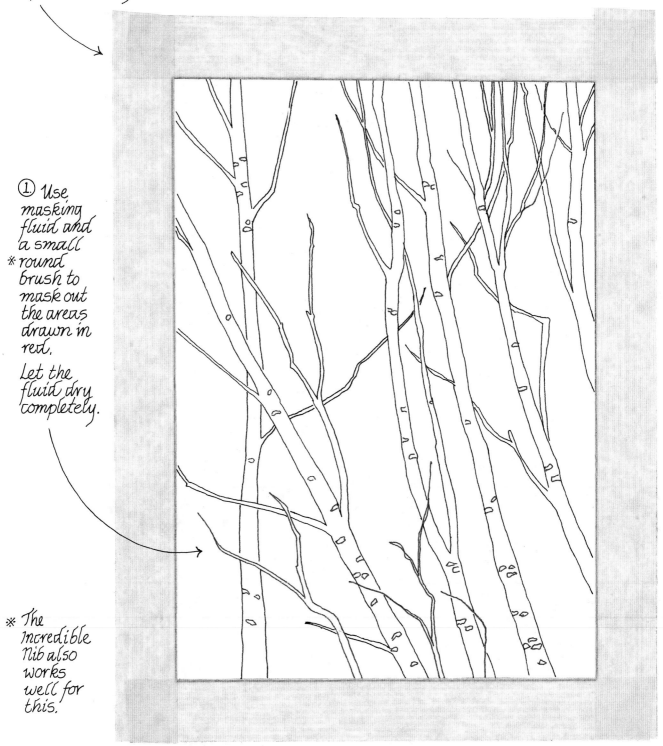

② Mix Burnt Sienna and Payne's Gray together to create a neutral gray-brown. Thin it with water to a light value. ──→

Use a no. 4 round brush to paint all the trunks and branches gray-brown. Let the paint dry.

Remember that paint lightens in value as it dries.

③ Carefully stroke, masking fluid over the brown branches and trunks. Try not to get it in the background area.

Allow the masked trees to dry.

The yellowish branches and spots represent previously masked areas.

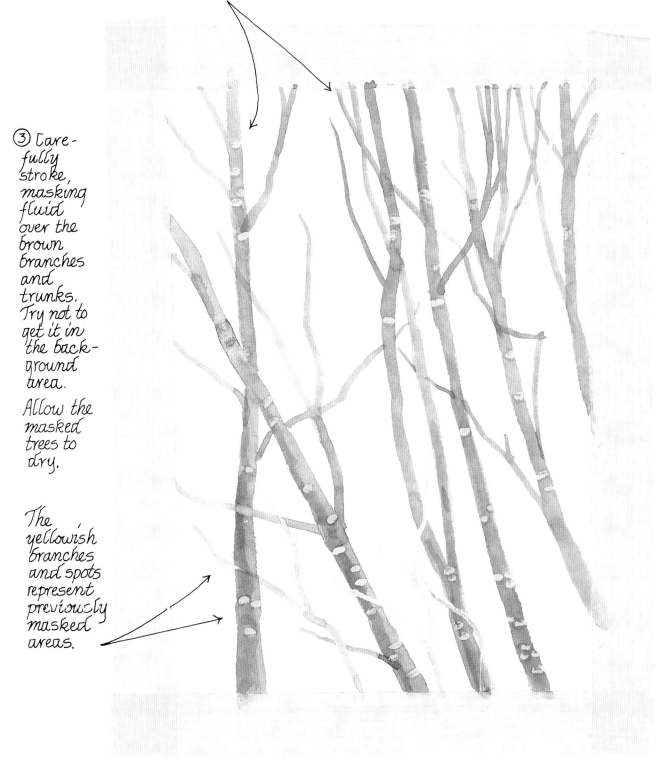

Basecoat - Cadium Yellow plus Burnt Sienna (very pale).

(A) - Cadmium Yellow plus Burnt Sienna (stronger value).

(B) - Burnt Sienna

(C) - Burnt Sienna plus Sap Green.

④. With the trees safely protected with masking fluid, the background can be laid down quickly. Paint the basecoat mixture over the whole painting. Apply it to a damp surface with a half-inch flat brush or large round brush.

This is a focus area created by dark branches against a pale, untextured background. Let the base coat show through.

⑤ While the basecoat is still moist (not runny wet), dab in background texture using color mixes A, B and C and the tip of a no. 4 round brush. Allow the colors to mingle spontaneously. Caution: over-blending the dabbed background will create a monotone of brown mud.

⑥ When the background is completely dry, remove the masking. Some of the pigment will lift away leaving the trunk a lighter value.

The masking tape can be removed now or left on until the painting is finished.

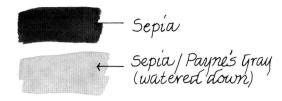 Sepia

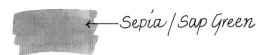 Sepia / Payne's Gray (watered down)

Sepia / Sap Green

⑦ Use the three colors shown to the left and a no. 4 round brush to shade and texture the tree trunks and branches.

The dark trunk patches represent clumps of moss and lichen. Keep the depiction of these moss clumps loose. Let them hang over the edge of the trunk.

Use the lighter color mixtures to shade the trunks and large branches. Leave the edges unblended.

Leave the white spots. They are part of the alder tree's coloration and provide great contrast.

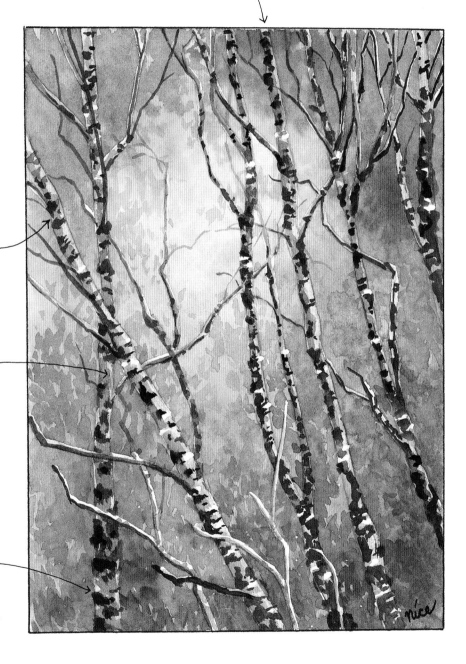

Mastering the Basic Washes

Learning to "pull" or lay down a controlled wash

is as vital to the watercolor artist as a child's first steps. Just as a child can never hope to walk, run or leap obstacles until those first steps are taken, the watercolorist must understand and master the simple washes in order to use them as stepping stones to greater achievements. In this chapter, I'll acquaint you with the terms and techniques behind those "first step" washes, and then guide you step by step through their application. I'll help you troubleshoot your stumbles and show you how to turn those missteps into textural techniques you can recall for future use. The practicing is up to you. Make washes, lots of them. Don't be afraid to use paper. It's not wasted; it's invested in developing your watercolor skills. Jot down notes beside those wash results, what worked, what didn't and why. Study the troubleshooting pages in this chapter to help you figure out the "whys" if your washes turn out less than adequate. You can form a notebook out of those practice sheets, which could prove a valuable reference source as well as a reminder of how much you've improved, as you progress with your watercolor painting.

The Drying Process

A wash passes through four stages after being spread on the paper. The paper surface, the amount of moisture involved and the climate will dictate the length of each stage, which can be as short as a few seconds. Knowing the characteristics of each step of the drying process can help the watercolorist achieve the desired effects while manipulating the paint.

First stage:

Appearance - Wash is freshly laid, wet and shiny.

Status - Paint is fluid, with pigment suspended throughout the liquid.

Workability - Wash is brushable, blendable and bruisable. Blotting works well. Also wet-on-wet techniques.

Cautions - Avoid flooding and backruns. Remove pools of standing liquid and beads of moisture left by the final brush stroke.

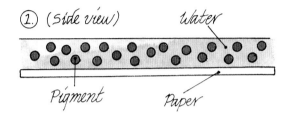

① (side view) Water

Pigment Paper

Second stage:

Appearance - A sheen of moisture is still apparent.

Status - Wash is less fluid. Water has been partially absorbed. Pigment is settling onto the paper.

Workability - Flow-altering techniques such as salt, alcohol, water spatter and impressed texturing are effective. Scraping works well.

Cautions: Pigment is easily disturbed by the introduction of additional liquid or brush work. Blotting may leave color residue.

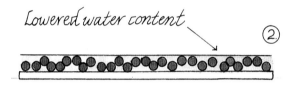

Lowered water content ②

Third stage:

Appearance - Sheen is gone. Paper feels damp and cool.

Status - Water is almost gone. Pigment has settled against the paper and is bonding into the fibers.

Workability is poor. Stroking with a damp brush and blotting may produce a partial lift.

Cautions - Wash may still be susceptible to water spotting and bleeding if brushed with liquid.

③ Gum arabic helps pigment particles disperse evenly and bond to the paper fibers.

Heavy pigment ④.

Thin wash - light pigment

Fourth stage:

Appearance - Dry.

Status - Pigment has bonded to paper.

Workability - Wash is ready to be glazed, dry brushed or razor scraped.

Cautions - A heavily pigmented wash may bleed if remoistened and brushed.

The Basic Flat Wash

Flat washes are thin mixtures of water and pigment that are brushed quickly and evenly across the surface of the watercolor paper to form smooth, colored areas of uniform tone.

Flat washes are useful to depict distant background objects or smooth flat surfaces. They form an undercoat for glazing and are the first step in many texturing techniques.

Wash mixtures contain mostly water, to which small amounts of pigment are added.

Thin wash	Medium wash	Heavy wash
Very little pigment in the mixture. Color is pale.	Enough pigment is added to produce a color of medial strength.	The color tone of this wash is strong and bold, containing a lot of pigment. The consistency is thinner than cream, flowing readily from the brush.

Keep in mind that watercolor washes will dry to a slightly lighter value than they appear when first laid down on paper.

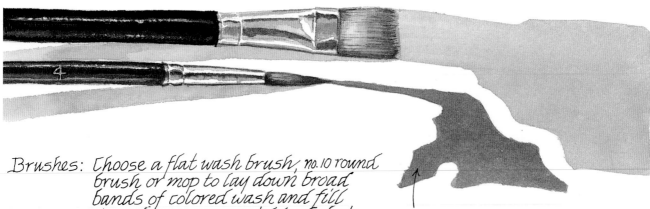

Brushes: Choose a flat wash brush, no. 10 round brush or mop to lay down broad bands of colored wash and fill in a large area quickly. Select the largest size you have that will work comfortably and accurately in the designated wash site. The fewer strokes you take, the smoother your flat wash will appear.

Choose a round brush to fill in small, narrow or irregularly shaped wash areas.

Remember that hair brushes hold more fluid than synthetics and will fill in an area faster.

This simple background barn was created with a series of flat washes. It was laid out with a pencil outline, then the wash areas were filled in. Care was taken that two wash areas did not touch while both of them were moist.

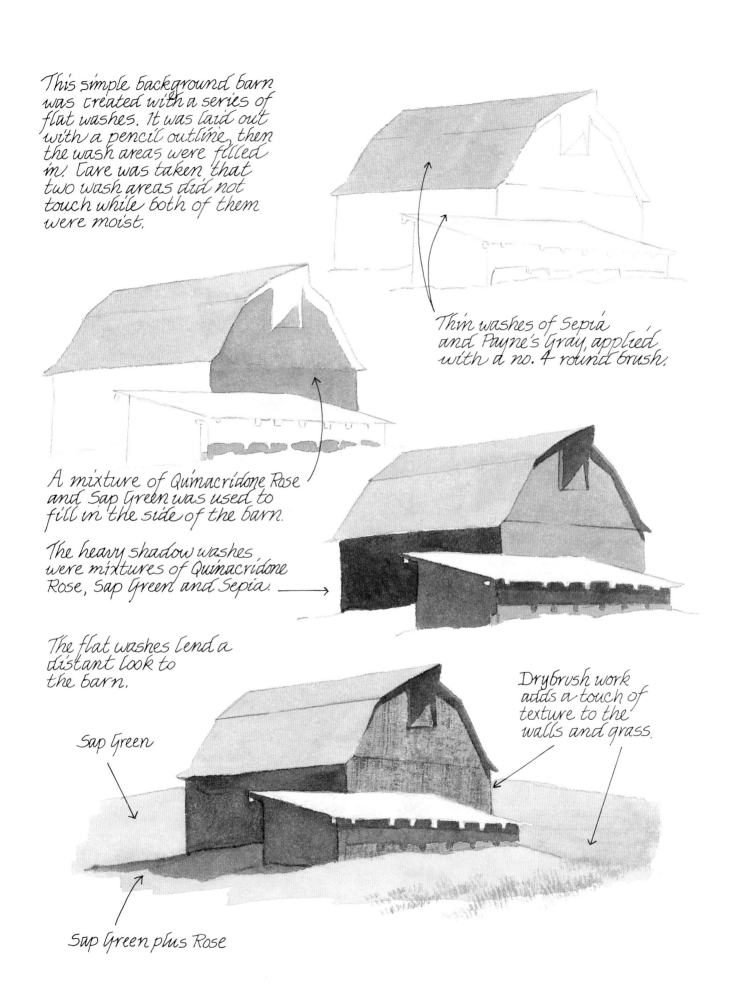

Thin washes of Sepia and Payne's Gray, applied with a no. 4 round brush.

A mixture of Quinacridone Rose and Sap Green was used to fill in the side of the barn.

The heavy shadow washes were mixtures of Quinacridone Rose, Sap Green and Sepia.

The flat washes lend a distant look to the barn.

Sap Green

Dry brush work adds a touch of texture to the walls and grass.

Sap Green plus Rose

Applying The Flat Wash

Choose to work on a dry surface
if the area to be covered is fairly
small and precise, hard edges
are desired. Work on a damp
surface if the area to be covered
is large.

① Begin by mixing up an adequate-
sized wash puddle on your palette
and test its strength on a paper
towel.

② Dip your brush in the wash puddle,
then touch the tip _lightly_ to a paper
towel to remove the excess paint. This
will prevent an uncontrolled flow
when you begin painting.

Work on a 10 - 30 degree slant.

③ Stroke the filled brush across the
top of the designated wash area
keeping the work surface tilted
enough to cause excess fluid to
flow downward to the bottom edge.

A bead of gathered moisture should collect at the bottom of each stroke.

④ Your second brush stroke should
be placed just over the previous
brush mark, and mostly over the
unpainted paper surface. As you
proceed across the paper, the
excess paint from the first stroke
will be picked up and spread by
the brush into the area covered
by the second stroke. Excess fluid
will again gather along the
bottom edge to be picked up and
spread by the third stroke.
Work rapidly so edges will remain
moist and workable.

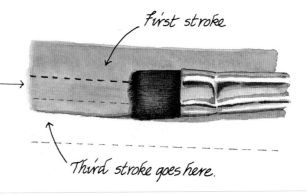

first stroke

Third stroke goes here.

Dip and blot your brush as much
as is necessary to keep the paint
flowing readily. A brush that is
too dry will create skip marks.

skip marks

⑤ Continue filling in the designated wash area with overlapping strokes so that excess fluid is picked up and moved downward toward the bottom. Use only as many strokes as you absolutely need to, to accomplish the task. This flat wash was laid down in six strokes.

Avoid the temptation to "play" in the completed wash!

⑥ Collect any excess fluid along the bottom edge of the wash by wicking it up into a clean, damp brush. Touch the tip of a round brush or the corner of a flat brush to the top of the bead of liquid and allow the moisture to be pulled up into the brush. Pushing the brush onto the paper will result in a light blot mark.

⑦ Let the pigment settle and dry undisturbed. To avoid blooms or unplanned paint mixtures, do not lay a new wash next to a previously painted one until the first wash is "bone dry."

Ideally the flat wash will dry perfectly smooth with a nice even tone.

If the wash dries slightly streaked, don't despair. Watercolor can be a bit independent even in the hands of experts. Keep in mind that few things in nature are perfectly smooth anyway. Keep practicing!

Troubleshooting A Less-Than-Perfect Flat Wash

Wash mixture too thick—

Thick, sticky wash mixtures spread unevenly.

Overworked wash —

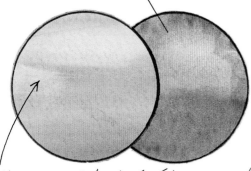

When a wash is stroked too many times, it begins to lift and spread unevenly.

Hard edge marks—

The edge of the wash was allowed to dry before the next stroke was applied.

Burnt Sienna

Sap Green

Perfect flat washes for comparison

Streaked appearance—

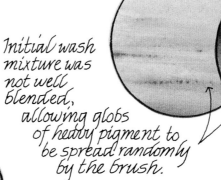

Initial wash mixture was not well blended, allowing globs of heavy pigment to be spread randomly by the brush.

Scrubbing—

Tired paper marks.

When washes are repeatedly blotted and reapplied or scrubbed with a stiff brush, the paper "tires" and begins to "ball up."

Foreign body in wash—

Dog hair dried in wash.

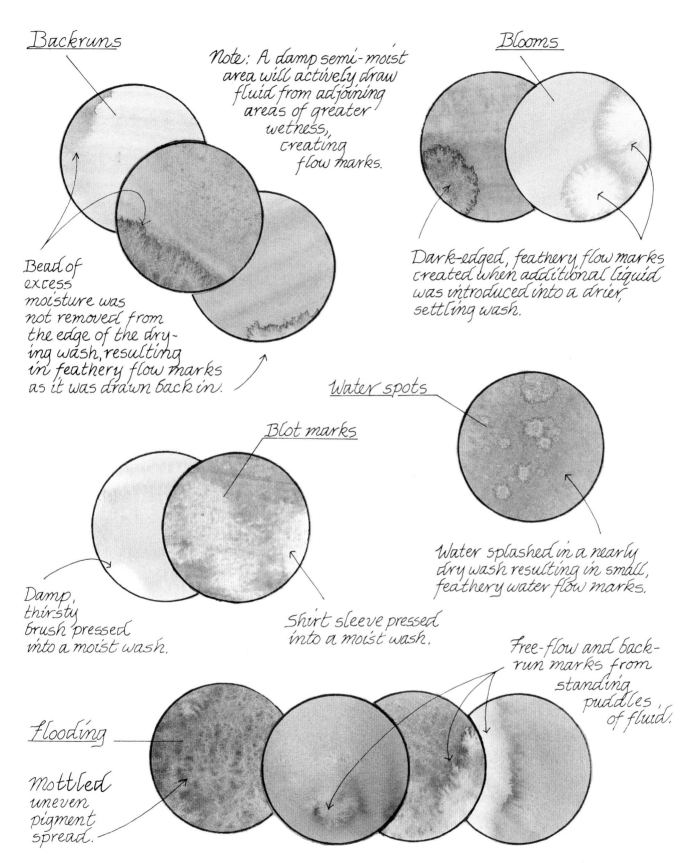

Backruns

Note: A damp semi-moist area will actively draw fluid from adjoining areas of greater wetness, creating flow marks.

Blooms

Bead of excess moisture was not removed from the edge of the drying wash, resulting in feathery flow marks as it was drawn back in.

Dark-edged, feathery flow marks created when additional liquid was introduced into a drier, settling wash.

Water spots

Blot marks

Water splashed in a nearly dry wash resulting in small, feathery water flow marks.

Damp, thirsty brush pressed into a moist wash.

Shirt sleeve pressed into a moist wash.

Free-flow and back-run marks from standing puddles of fluid.

Flooding

Mottled uneven pigment spread.

When the paper is wet or the brush is super loaded with fluid, the wash may free-flow in an unpredictable manner.

The Graded Wash

In the graded wash there is a smooth, subtle change from dark or medium value to a lighter value or vice versa.

Graded washes are useful in portraying clear summer skies, pools of still water and the contours of human skin. The technique works well to create soft, indistinct edges and to suggest the curves of hard, smoothly rounded objects.

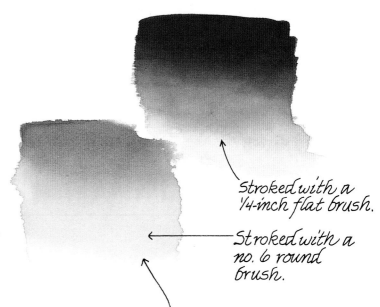

Stroked with a 1/4-inch flat brush.

Stroked with a no. 6 round brush.

Soft, indistinct edge

Graded wash sky

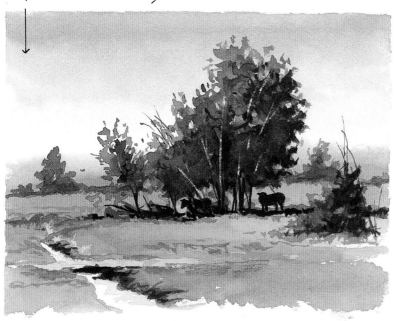

Graded washes are applied to a damp surface to help the pigment flow nicely and the wash itself to stay moist and workable for a longer period of time.

Basically the value change, in the graded wash is brought about by adding increasingly greater amounts of water to the wash puddle on the palette as the work progresses. The greater the water in the mix the lighter the value will be.

As you prepare the preliminary wash puddle on your palette, imagine the graded wash and how dark you want the darkest area of that graded wash to be. Strive for a value that will be slightly darker than you had in mind. Remember that washes lighten in value as they dry. Test it on a paper towel.

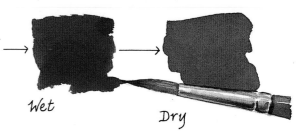

Wet

Dry

Applying the Graded Wash

Preparation: Have two tubs of clear water on hand. Create a wash puddle of adequate size and value to do the job. Your watercolor paper should be taped to a board and predampened in the area to be worked.

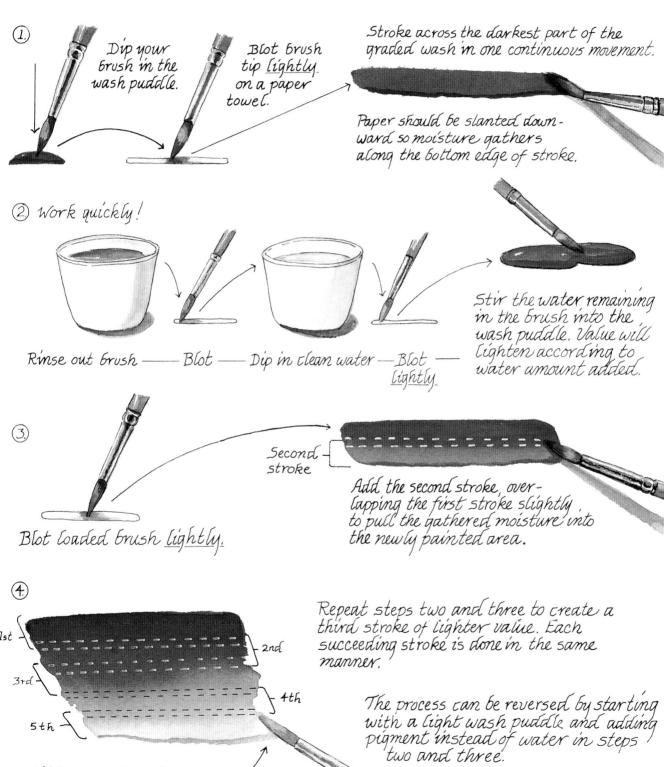

① Dip your brush in the wash puddle.

Blot brush tip _lightly_ on a paper towel.

Stroke across the darkest part of the graded wash in one continuous movement.

Paper should be slanted downward so moisture gathers along the bottom edge of stroke.

② Work quickly!

Rinse out brush —— Blot —— Dip in clean water —— Blot lightly

Stir the water remaining in the brush into the wash puddle. Value will lighten according to water amount added.

③ Blot loaded brush _lightly._

Second stroke

Add the second stroke, overlapping the first stroke slightly to pull the gathered moisture into the newly painted area.

④ 1st 2nd 3rd 4th 5th

Repeat steps two and three to create a third stroke of lighter value. Each succeeding stroke is done in the same manner.

The process can be reversed by starting with a light wash puddle and adding pigment instead of water in steps two and three.

Wick up gathered moisture.

Troubleshooting the Less-Than-Perfect Graded Wash

Perfect graded washes for comparison.

Striped Appearance
This occurs more often when using flat brushes than round.

Flat brushes often need to be worked in a series of short, partially repeated dabbing strokes to help soften and blend the edges.

Color Contamination
Brush was dipped in the dirty water before diluting the wash puddle.

Wet-on-wet flow
Paper too moist.

Hard Edge
Paper was too dry or artist waited too long between strokes.

Backrun

Paper was worked flat. Moisture beads that gathered at the end of each stroke were not removed.

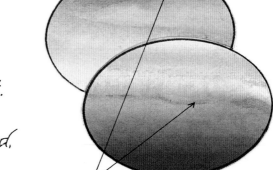

Abrupt value change
Too much water was added to the wash puddle between strokes.

Streaks and partial lift marks
Both of these washes were "played in" while they were trying to dry.

Practice Exercise

This parchment scroll provides the opportunity to practice both the graded wash and the flat wash.

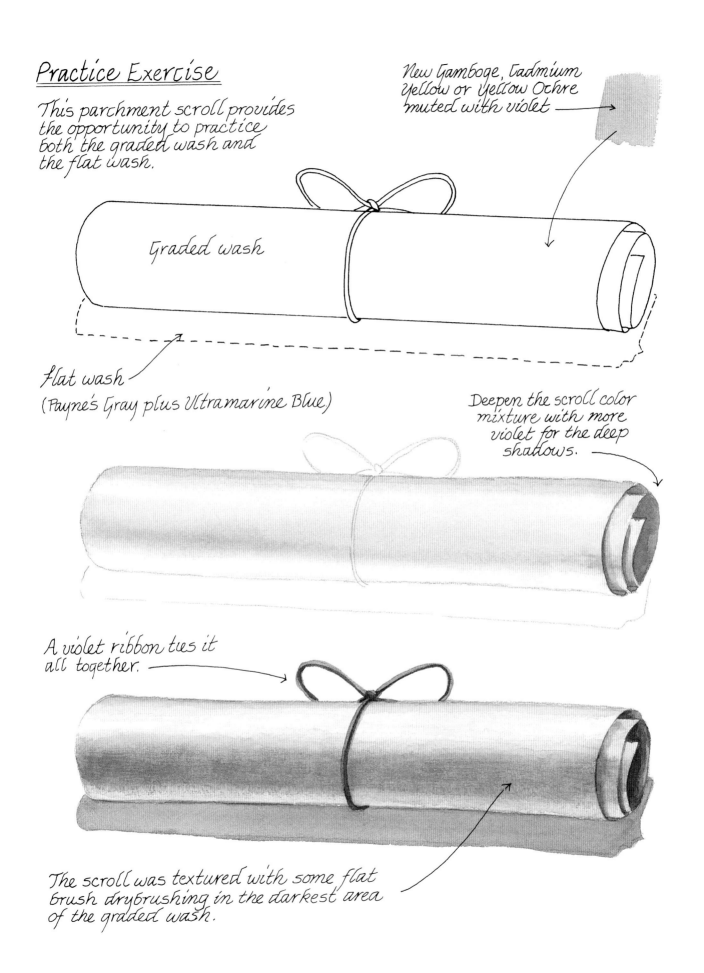

New Gamboge, Cadmium Yellow or Yellow Ochre muted with violet

Graded wash

Flat wash
(Payne's Gray plus Ultramarine Blue)

Deepen the scroll color mixture with more violet for the deep shadows.

A violet ribbon ties it all together.

The scroll was textured with some flat brush drybrushing in the darkest area of the graded wash.

Producing Subtle Color Change

A technique similar to the one used for the graded wash can be used to create a gradual, blended color change. Try it out with this exercise.

Preparation: Tape the paper to a backing board so it can be slanted downward. (Surface- slightly damp) Create two wash puddles on your palette, one of warm yellow (a) and one of Burnt Sienna (b).

(a)

(b)

① Fully load the brush (no. 10 round) with yellow wash and blot it lightly on a paper towel.

② Use several overlapping strokes to apply the yellow paint, allowing the excess moisture to gather along the bottom edge. Renew the brush in the yellow wash puddle as needed to maintain the flow and moisture. When finished, clean and blot the brush.

③ Stir a drop of Burnt Sienna into yellow wash puddle (a). Blot the brush lightly and stroke across the work area. Overlap the wet yellow paint slightly, picking up the moisture bead as you move along. The colors will flow together naturally.

Nicely graded color blend.

④ Stir a little more Burnt Sienna into wash puddle (a). Continue painting, overlapping the wet previously painted area slightly to mingle the colors. The moisture bead should be picked up and moved along with each stroke. Work as quickly and as smoothly as possible.

Streaky, overworked wash!

Wick up moisture bead when finished.

Charging a Color Change

This is a more direct way of creating a color change in a wash. The change of hue takes place in the moisture bead of the painted area rather than being pre-mixed on the palette. The result is more bold and spontaneous. Here's how it works.

slant

maintain a nice, fluid moisture bead along the lower edge.

Ⓐ Begin the same way as the graded color change on the opposite page. Follow steps one and two. Keep the two wash puddles fairly thin and similar in value. (The diagonal slant of this wash is to demonstrate that washes can be created in all directions. Simply rotate the paper and backing board so the gentle downward tilt is in the right direction.)

(a)

(b)

Ⓑ Rinse out and blot the brush. ⟶

Ⓒ Load the brush in wash puddle (b).

Ⓓ Tap the loaded brush tip into the top of the moisture bead, moving all along the bottom edge. Fluid from the paint-filled brush will flood or "charge" into the yellow paint, mingle and create a spontaneous color blend.

When finished wick 'up the remaining excess moisture with a blotted brush.

Ⓔ Catch the moisture bead of blended color and continue painting with overlapping strokes. Don't let the bead of moisture dry up. Re load the brush and charge in more wash fluid as needed. The painted area will become browner each time the bead is "charged."

Moisture bead was not adequate. (Poor blend)

Burnt sienna wash was too weak and was over run.

Variegated Washes

So far the washes in this chapter have been smooth and contrived, with subtle changes in value and color. Now it's time to learn how to spice up your washes with a little spontaneous texture.

Allow yourself to be a little careless as you work. Break a few rules and texture will happen!

Variegated washes are a mixture of imagination and unintentional occurrences. They are fun to create and hard to duplicate.

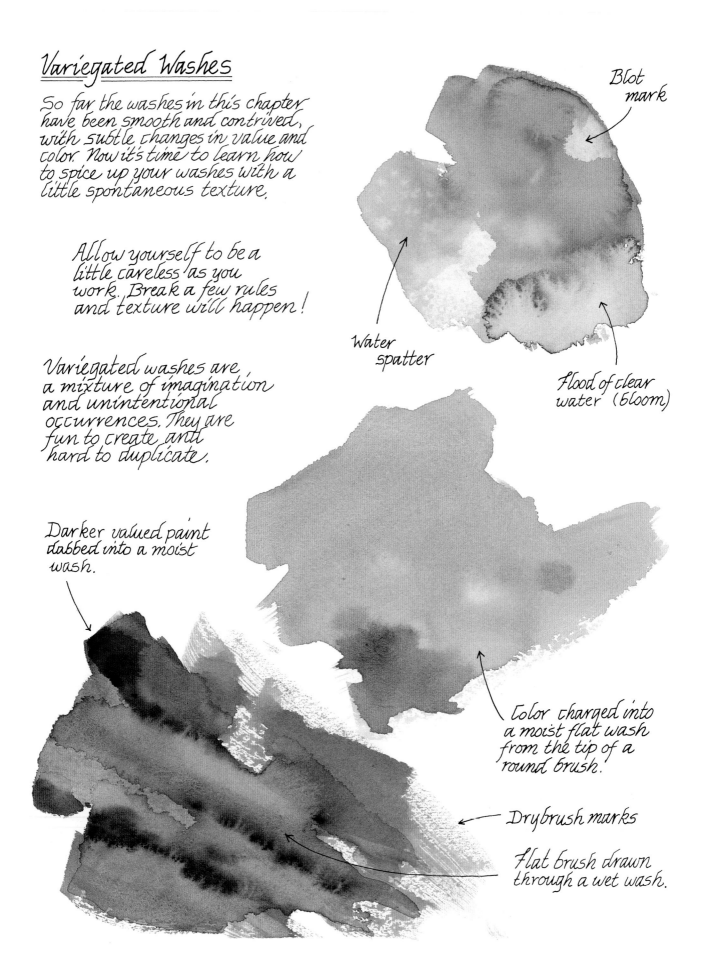

Blot mark

Water spatter

Flood of clear water (bloom)

Darker valued paint dabbed into a moist wash.

Color charged into a moist flat wash from the tip of a round brush.

Drybrush marks

Flat brush drawn through a wet wash.

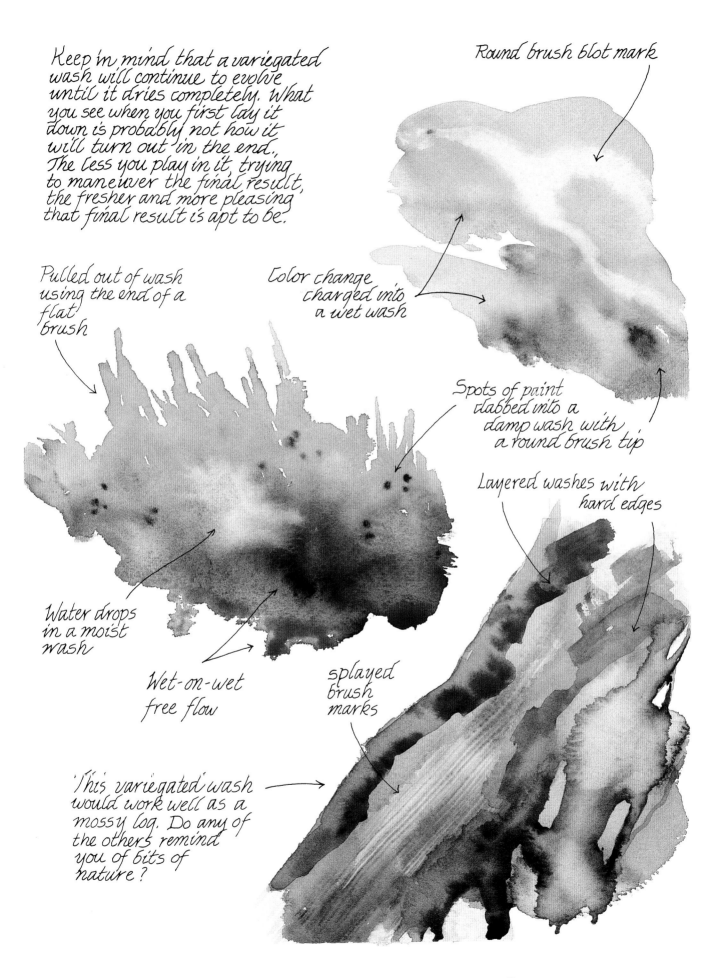

Keep in mind that a variegated wash will continue to evolve until it dries completely. What you see when you first lay it down is probably not how it will turn out in the end. The less you play in it, trying to maneuver the final result, the fresher and more pleasing that final result is apt to be.

Round brush blot mark

Pulled out of wash using the end of a flat brush

Color change charged into a wet wash

Spots of paint dabbed into a damp wash with a round brush tip

Layered washes with hard edges

Water drops in a moist wash

Wet-on-wet free flow

splayed brush marks

This variegated wash would work well as a mossy log. Do any of the others remind you of bits of nature?

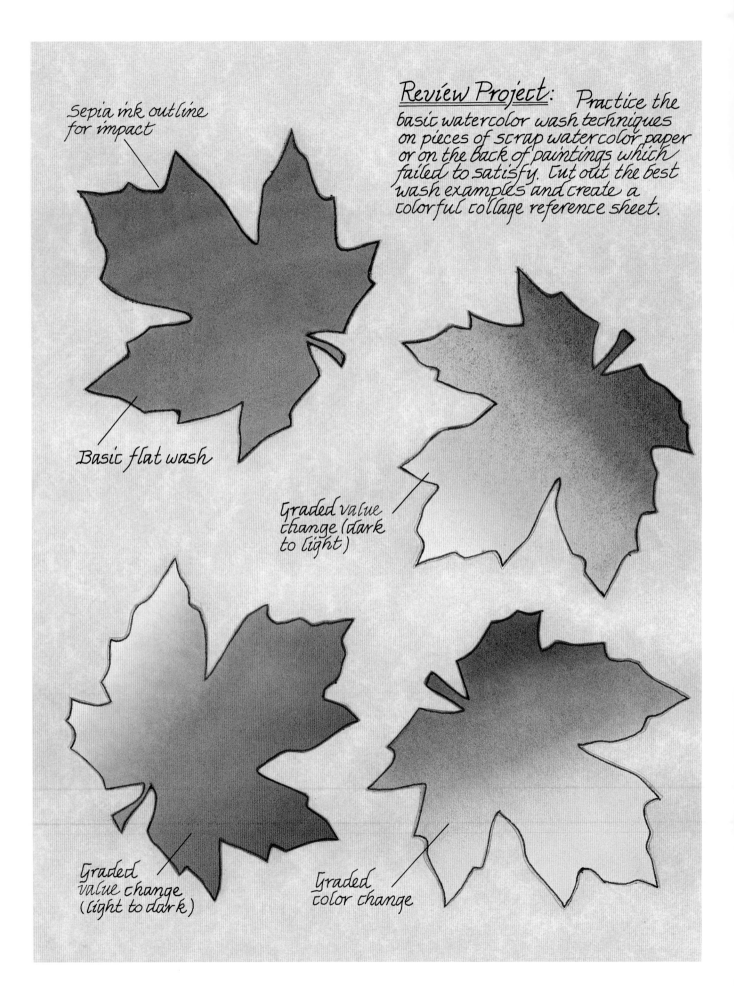

Sepia ink outline for impact

Review Project: Practice the basic watercolor wash techniques on pieces of scrap watercolor paper or on the back of paintings which failed to satisfy. Cut out the best wash examples and create a colorful collage reference sheet.

Basic flat wash

Graded value change (dark to light)

Graded value change (light to dark)

Graded color change

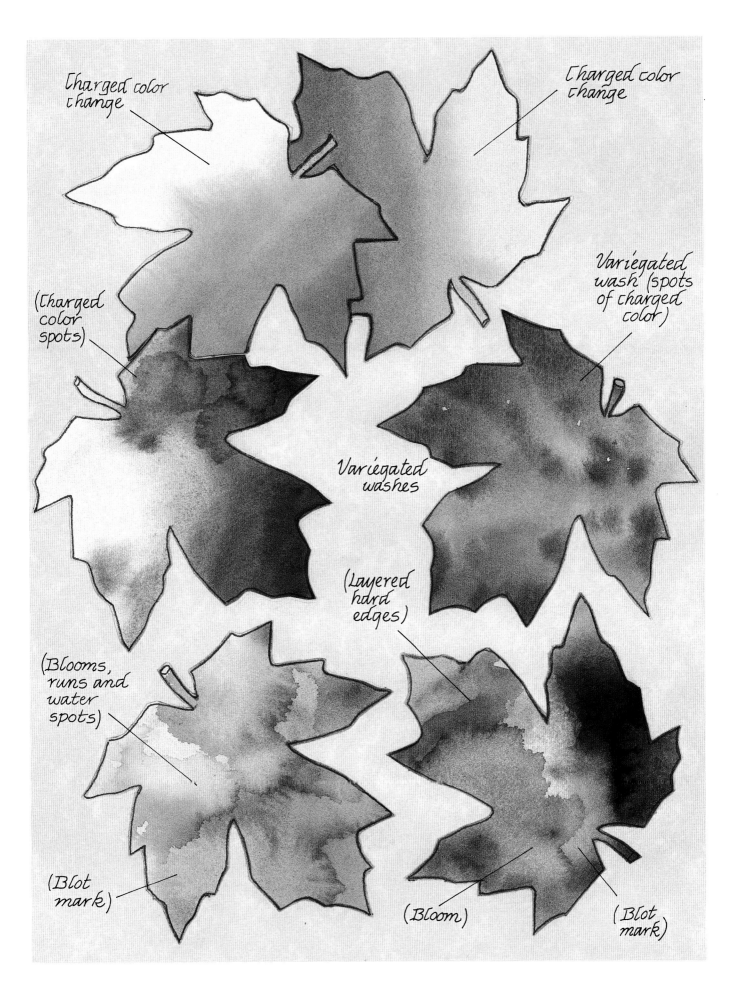

Charged color change

Charged color change

(Charged color spots)

Variegated wash (spots of charged color)

Variegated washes

(Layered hard edges)

(Blooms, runs and water spots)

(Blot mark)

(Bloom)

(Blot mark)

Becoming Familiar with Glazing and Layering

Color mixtures can be created in several ways. The

simplest is to stir together two wash puddles of different hues on the palette. The result is immediate and safe. Graduated blends, wet-on-wet free-flows and charging techniques are more adventurous. They depend a lot on skill, but also on luck and the whim of the materials being used.

A third way of combining colors is to keep them separate! One separate transparent wash is placed over another like the stacking of two colored pieces of glass over a light box. The eye will see an "optical color mixture," a combination of the two transparent color layers where no real mingling of the pigments has taken place. This optical color mixture is called glazing.

Glazing depends on several factors to be successful. The wash layers must be thin to allow the base color to show through. Before each new color glaze is added, the wash beneath must be dry. To avoid disturbing the dry layer beneath, the glaze should be applied quickly and with minimal brush action.

Layering is the same process but heavier washes are used. The idea is to block out some or all of the lighter undercoat to create bold value changes, silhouetted shapes, or to "cover up" an undesired area.

In the storm cloud study (opposite page), the entire painting was blocked in using various values of Cobalt Blue. The painting was then glazed with Gamboge or Burnt Sienna, with the upper clouds and the side of the house left white for contrast. A dark mix of Cobalt Blue and Cadmium Orange was layered over the trees and shadows to emphasize their silhouette appearance.

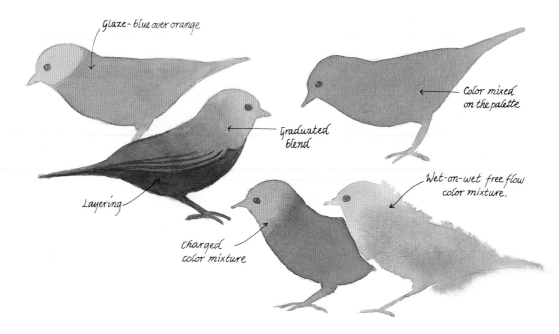

Glaze - blue over orange

Color mixed on the palette

Graduated blend

Wet-on-wet free flow color mixture.

Layering

charged color mixture

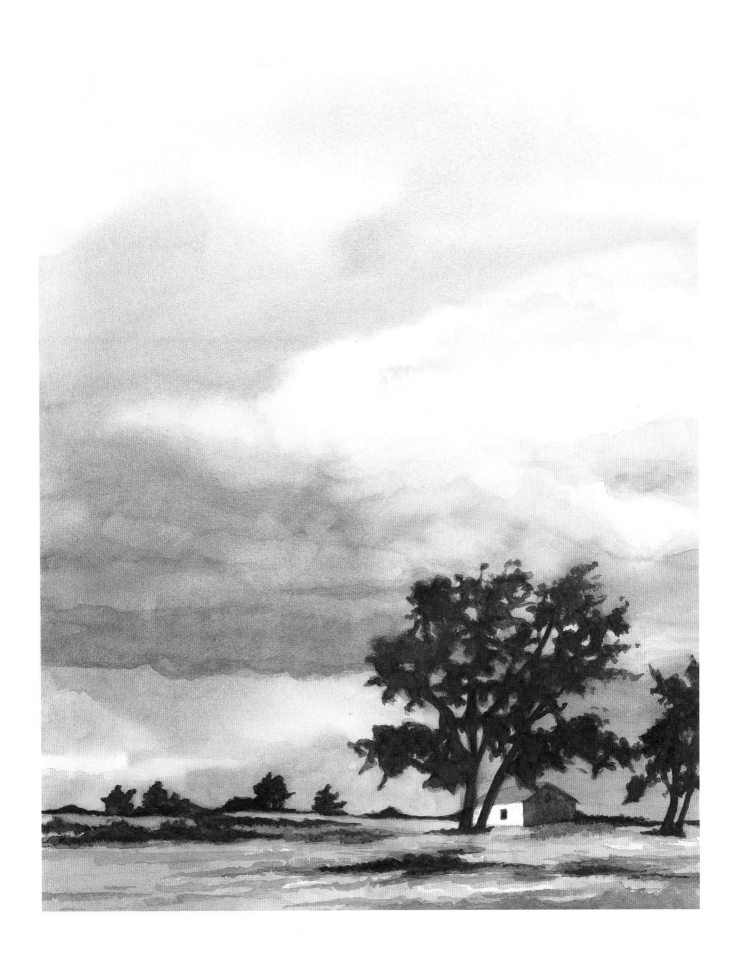

A Variety of Glazed Effects

	Base color	Glaze color	First glaze	Second glaze

Intensify Color

To richen pale washes, add a glaze or two of the original color.

Pale yellow	Pale yellow
Pale red	Pale red
Pale blue	Pale blue

Change the Color

Stroking a glaze over a base coat of a distinctly different hue will create an optical color change. Analogous colors (those near each other on the color wheel) make the most vivid combinations.

Blue	Green
Light green	Cool yellow
Yellow	Orange
New Gamboge	Warm red
Warm red	Cool red (rose)
Cool red (rose)	Violet

These lively, glazed color mixtures are especially nice for florals.

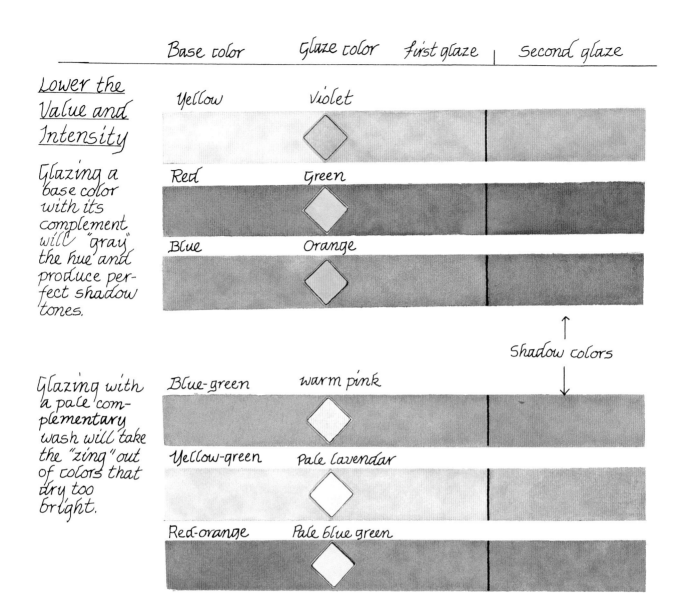

Lower the Value and Intensity

Glazing a base color with its complement will "gray" the hue and produce perfect shadow tones.

Glazing with a pale complementary wash will take the "zing" out of colors that dry too bright.

Yellow — Violet

Red — Green

Blue — Orange

Shadow colors

Blue-green — warm pink

Yellow-green — Pale lavendar

Red-orange — Pale blue green

When glazing, keep in mind that the optical color change is not complete until the paint dries. Glazes that look shocking or dominate when first applied tend to tame down considerably as they settle in. If needed, a thin "adjustment glaze" can be added to change the color, lower the intensity or darken the value once the underlying glaze is dry. However, keep the number of glazes to a minimum (three or less is best). Over glazing leads to mud.

Hint: Don't throw away unsuccessful watercolor paintings. The backsides are a perfect place to experiment with new glazing combinations. Cut them out and glue them into a reference book. A few notes will help you remember the exact colors used.

Glazing and Layering—
Step by Step

① Sketch out a pansy flower and prepare two wash puddles on the palette-- Cadmium Yellow and Ultramarine Blue

② Use a no. 4 brush and paint the main body of the pansy yellow and the back petal blue. Let the first color dry before painting the second one.

Applied to a damp surface.

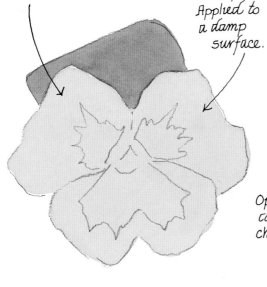

③ When the base washes are dry, prepare a thin wash of Quinacridone Rose on the palette and glaze it over the blue and yellow undercoat. Some of the base coat may be left unpainted.

Optical color changes.

Unglazed area.

④ If a deeper, more intense color is desired, a second thin glaze of rose may be applied after the first glaze is dry.

Some of the first glaze was left unpainted.

Two layers were applied.

⑤ Prepare a heavy wash (dark not thick) and layer it over the dry glazes to block out the orange and create a velvety beard. Shade the throat and back petal.

Violet plus Payne's Gray.

Troubleshooting
Imperfect Results

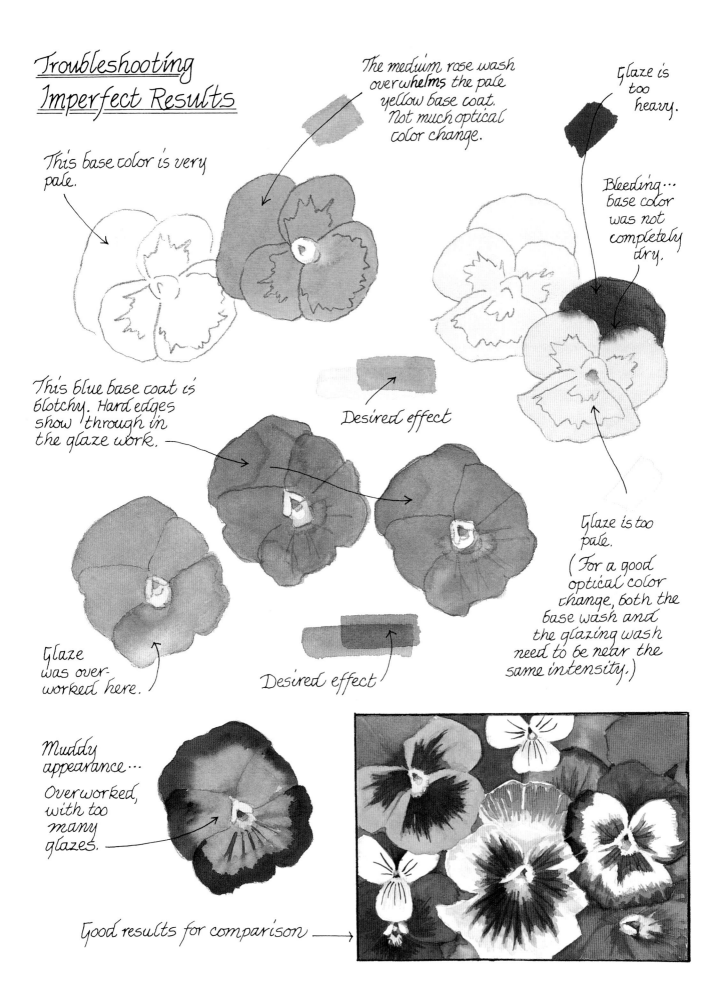

The medium rose wash over**whelms** the pale yellow base coat. Not much optical color change.

This base color is very pale.

Glaze is too heavy.

Bleeding... base color was not completely dry.

This blue base coat is blotchy. Hard edges show through in the glaze work.

Desired effect

Glaze is too pale.

(For a good optical color change, both the base wash and the glazing wash need to be near the same intensity.)

Glaze was over-worked here.

Desired effect

Muddy appearance...
Overworked, with too many glazes.

Good results for comparison

Depicting Glass

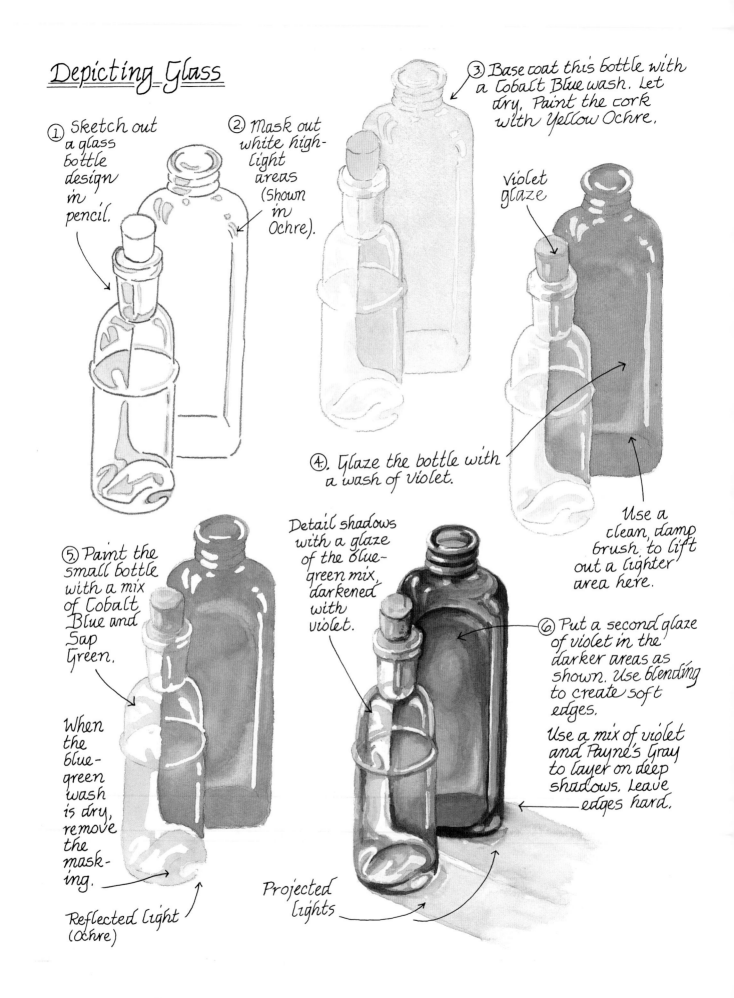

① Sketch out a glass bottle design in pencil.

② Mask out white high-light areas (Shown in Ochre).

③ Base coat this bottle with a Cobalt Blue wash. Let dry. Paint the cork with Yellow Ochre.

Violet glaze

④. Glaze the bottle with a wash of violet.

Use a clean, damp brush to lift out a lighter area here.

⑤ Paint the small bottle with a mix of Cobalt Blue and Sap Green.

When the blue-green wash is dry, remove the masking.

Reflected light (Ochre)

Detail shadows with a glaze of the blue-green mix, darkened with violet.

⑥ Put a second glaze of violet in the darker areas as shown. Use blending to create soft edges.

Use a mix of violet and Payne's Gray to layer on deep shadows. Leave edges hard.

Projected lights

Glazing a Wave

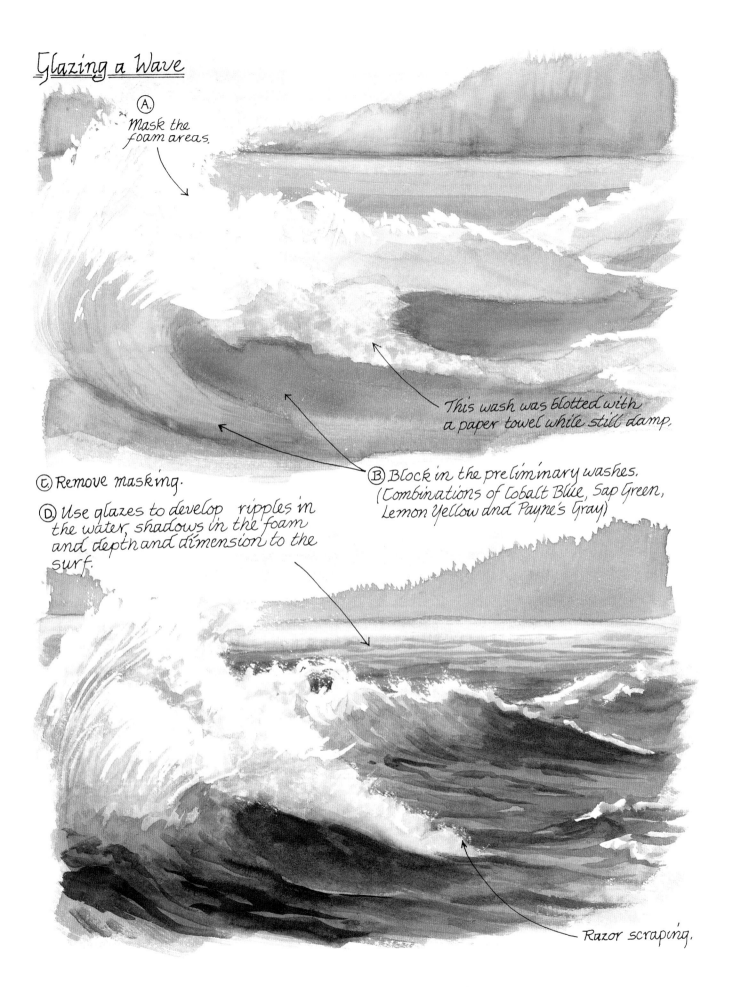

(A.) Mask the foam areas.

This wash was blotted with a paper towel while still damp.

(C) Remove masking.

(B) Block in the preliminary washes. (Combinations of Cobalt Blue, Sap Green, Lemon Yellow and Payne's Gray)

(D) Use glazes to develop ripples in the water, shadows in the foam and depth and dimension to the surf.

Razor scraping.

Layered Washes

Opaque or heavily pigmented washes can be layered over a dry undercoat or a series of glazes to develop greater value contrast in a painting. Layered washes are especially useful in suggesting deep shadow areas.

Shown below are the primary and secondary hues and some of the tube colors and mixtures that layer well over them.

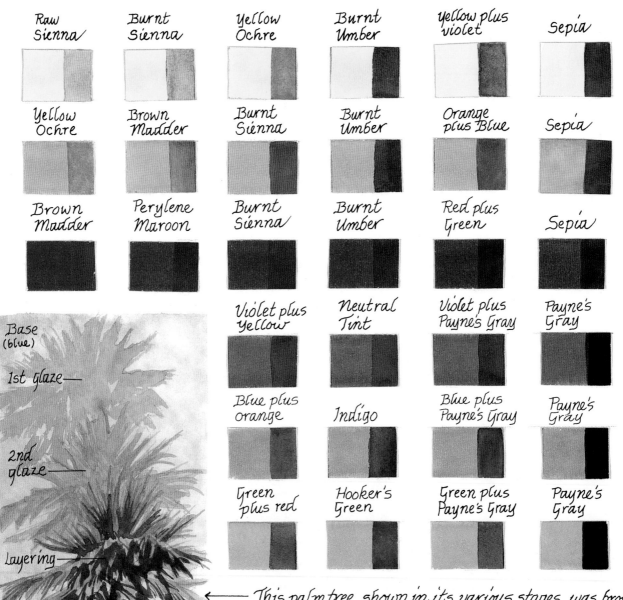

Raw Sienna Burnt Sienna Yellow Ochre Burnt Umber Yellow plus Violet Sepia

Yellow Ochre Brown Madder Burnt Sienna Burnt Umber Orange plus Blue Sepia

Brown Madder Perylene Maroon Burnt Sienna Burnt Umber Red plus Green Sepia

Violet plus Yellow Neutral Tint Violet plus Payne's Gray Payne's Gray

Blue plus orange Indigo Blue plus Payne's Gray Payne's Gray

Green plus red Hooker's Green Green plus Payne's Gray Payne's Gray

Base (blue)

1st glaze

2nd glaze

Layering

Several layers applied

←— This palm tree, shown in its various stages, was brought to life with the final layered washes. They cover up some of the underlying glazes and suggest deep, shadowy contours.

Note the other uses of heavy, layered washes in the watercolor painting shown on the opposite page — VICTORIAN TOWERS (8 x 10)

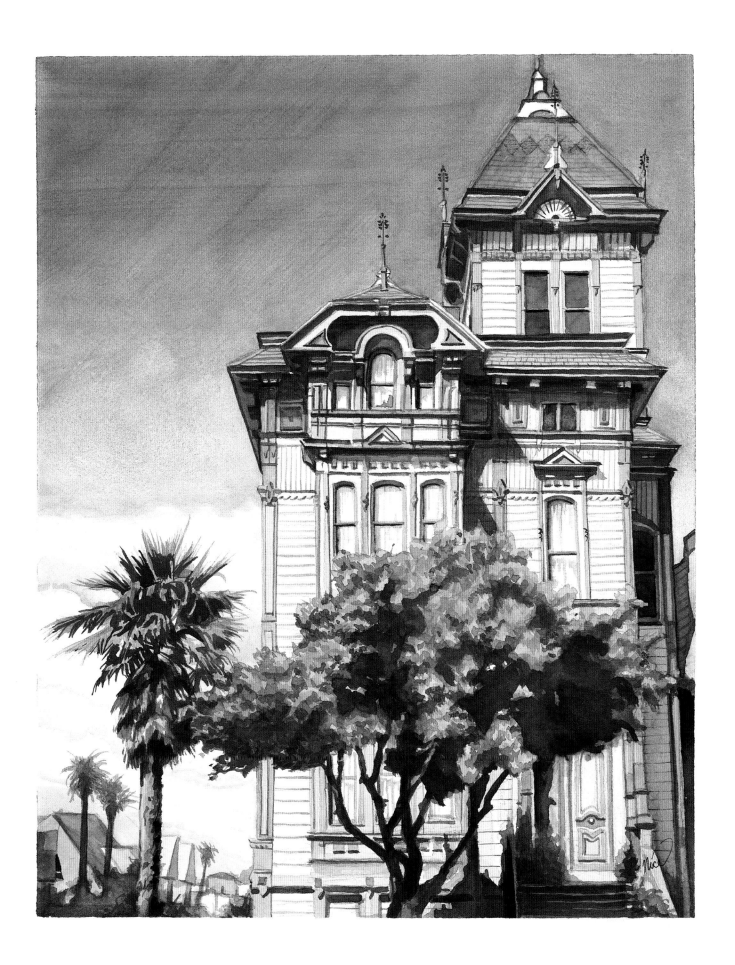

Glazing Form Shadows

Depicting the value changes that occur when light strikes an object will give a flatly drawn shape the illusion of being a three-dimensional form. A strong light area (highlight) occurs at a point on the object closest to the light source. Highlights are left unpainted. Increasingly darker areas of value occur on those portions of the object not receiving direct light (form shadows).

Flat circle - no light play shown.

Form shadows can be suggested effectively using glazing and layering techniques. Here's how--

① Draw or trace a circle and paint it with a pale blue-green wash. Let dry.

Leave the high-light dot un-painted.

Halo

Pale blue-green wash.

Blue-green wash darkened slightly with red-orange.

Soft edges

③ Repeat step two using a darker glaze. Allow some of the first glaze to show surrounding the halo and at the bottom right edge of the circle (Light reflected onto the sphere from the table-top). Soften edges and let dry.

② Using the same pale blue-green base wash, glaze the sphere. Leave a "halo" of the base coat to show around the highlight. Use a damp no. 4 round brush to blend and soften the edge of darker value. Work quickly before the glaze dries.

Blue-green plus red-orange.

Note ~ Glazing a perfect form shadow takes practice. As glaze layers build up, the paint can easily be disturbed by a vigorous damp brush. Be gentle as you soften hard edges!

④ Add a dark shadow with a heavily pig-mented layer of paint. Form a dark crescent on the lower right side of the sphere opposite the highlight dot. Leave the lighter edge of reflected light. Soften edges gently.

Reflected light

Cast shadow

Simple A.B.C. Glazing Projects

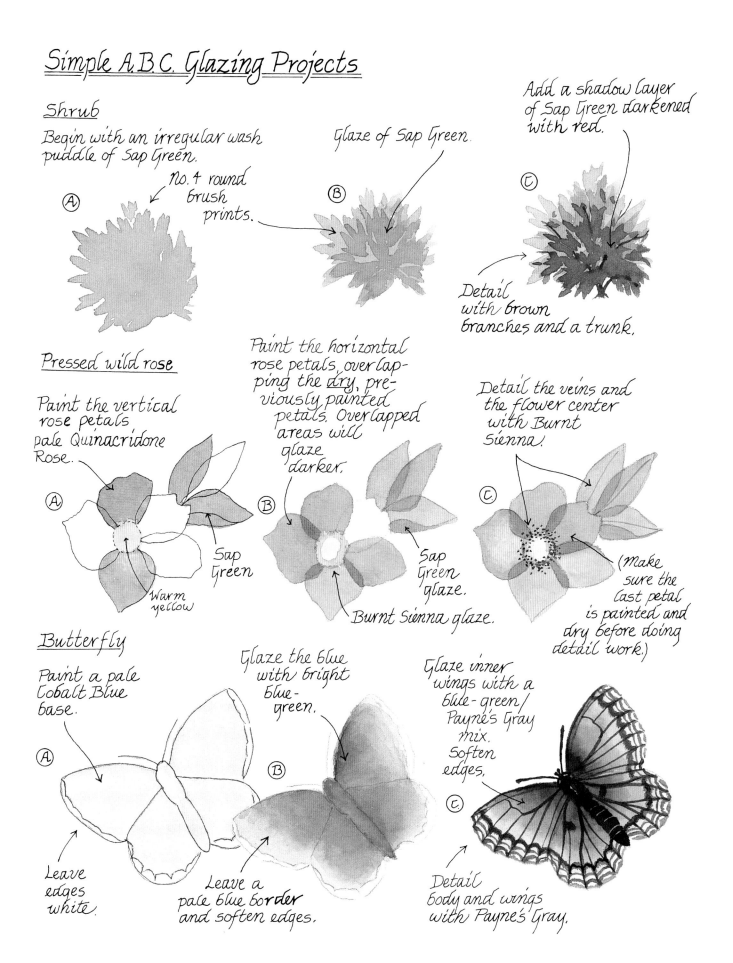

Shrub

Begin with an irregular wash puddle of Sap Green.

Ⓐ

No. 4 round brush prints.

Glaze of Sap Green.

Ⓑ

Add a shadow layer of Sap Green darkened with red.

Ⓒ

Detail with brown branches and a trunk.

Pressed wild rose

Paint the vertical rose petals pale Quinacridone Rose.

Ⓐ

Sap Green

Warm yellow

Paint the horizontal rose petals, overlapping the *dry*, previously painted petals. Overlapped areas will glaze darker.

Ⓑ

Sap Green glaze.

Burnt Sienna glaze.

Detail the veins and the flower center with Burnt Sienna.

Ⓒ

(Make sure the last petal is painted and dry before doing detail work.)

Butterfly

Paint a pale Cobalt Blue base.

Ⓐ

Leave edges white.

Glaze the blue with bright blue-green.

Ⓑ

Leave a pale blue border and soften edges.

Glaze inner wings with a blue-green/ Payne's Gray mix. Soften edges.

Ⓒ

Detail body and wings with Payne's Gray.

Experimenting with Application Techniques

Flip! Spatter! Splot! Ker-plop! Squish! These could

be the sounds of a superhero in action, but they're not! They're the sounds of an artist having fun applying paint in unconventional ways. You see, spreading the paint with a brush is not the only way to move it from the palette to the paper. In fact almost anything that will hold and transfer moisture can become a painting tool.

Sometimes the tool acts as a springboard from which the paint is sent flying onto the paper. In this technique, the paint can land as small flecks or larger splotch marks. It's called spatter, and the results are rough, wild and exciting.

When the application tool is soft and absorbent like a crumpled rag, sea sponge, gauze or cotton ball, the material can be dipped in paint and the texture of its surface printed upon the paper many times. This is the sponging technique. Flatter, firmer materials, like leaves, stiff lace, rubber templates, sliced vegetables, and fingertips, can be painted and pressed to the paper to "stamp" a print of the surface design. Stamped prints are meant to be clear and detailed, whereas sponging is a series of overlapping prints producing thick, fluffy, overlapping texture.

Examples of spatter, sponging and stamping are shown on this page. The backgrounds and vegetation seen in the miniature paintings (opposite page) began with similar application techniques.

spatter

sponging

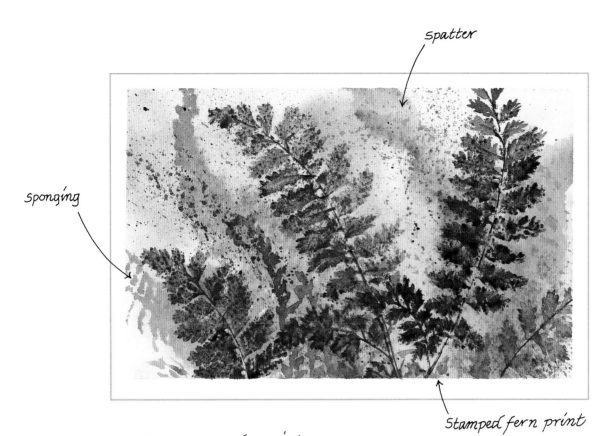

Stamped fern print

Gravel was stamped on with
a painted kitchen sponge.

Spatter

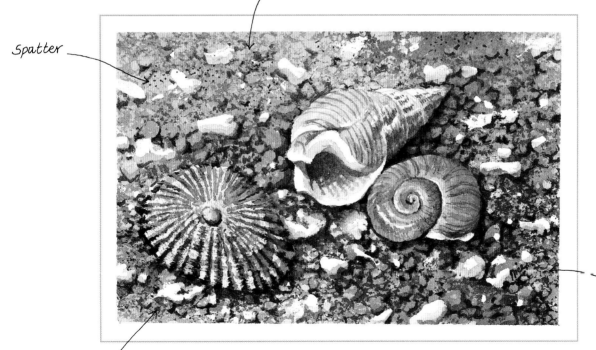

Kitchen
sponge
print

Shells and white fragments were masked.

Spatter

Simply put, spatter marks are spots, ranging from tiny flecks to small, irregularly edged splotches. They come about by being flicked, flipped or flung from a tool onto the paper surface. Where they land and the pattern they form is somewhat random.

Spatter is very useful for overlaying solid wash areas with speckled texturing. It helps suggest multi-particle substances such as soil, sand, water spray, pollen specks, etc.

Creating fleck marks

Toothbrush spatter-
spray flew another
two feet.

To create a wide pattern of specks, dip an old toothbrush in a wash puddle of paint and flick the bristles with your thumb or another stiff brush. The more vigorous the flicking action and the higher above the paper you hold the toothbrush, the more wide-flung the pattern will be. A wetter, more fully loaded brush will create bigger sized specks. The toothbrush method is wild, so cover areas and objects you don't want spotted.

A more controlled method for small spatter areas is to fully load a watercolor brush and flick it off your finger tip. (A flat brush creates a wide pattern and a round brush makes a narrow stripe.) Position your finger, nail side down, above the paper. Point the tip toward the spot you wish to spatter. Start a finger's width above the surface and raise it to widen the pattern. (If your nails are long, work off the side of your finger or a spoon handle.)

To create spatter, hold your finger still and stroke the brush downward against the tip with a vigorous motion. If no flecks appear, try a wetter mix on the brush.

If you object to having a colorful finger, don a rubber glove!

Stroke away
from finger tip.

A Variety of Spatter
(Applied with the finger-tip technique.)

Spatter on a dry paper surface.

Spatter over a dry wash.

Spatter over a moist surface.

Varied spatter

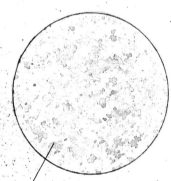

Moist spatter flicked with water drops.

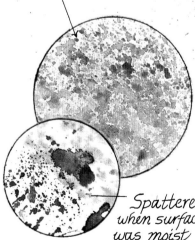

Spattered when surface was moist and again when dry.

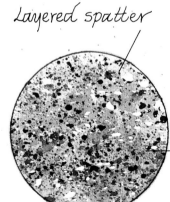

Layered spatter

Masking fluid spattered onto paper before the washes and other spatter were applied.

Splotches and Flung Paint

This technique is done primarily for the fun of it. It's a chance to unwind and creatively let go with the whim of the paint as an equal partner.

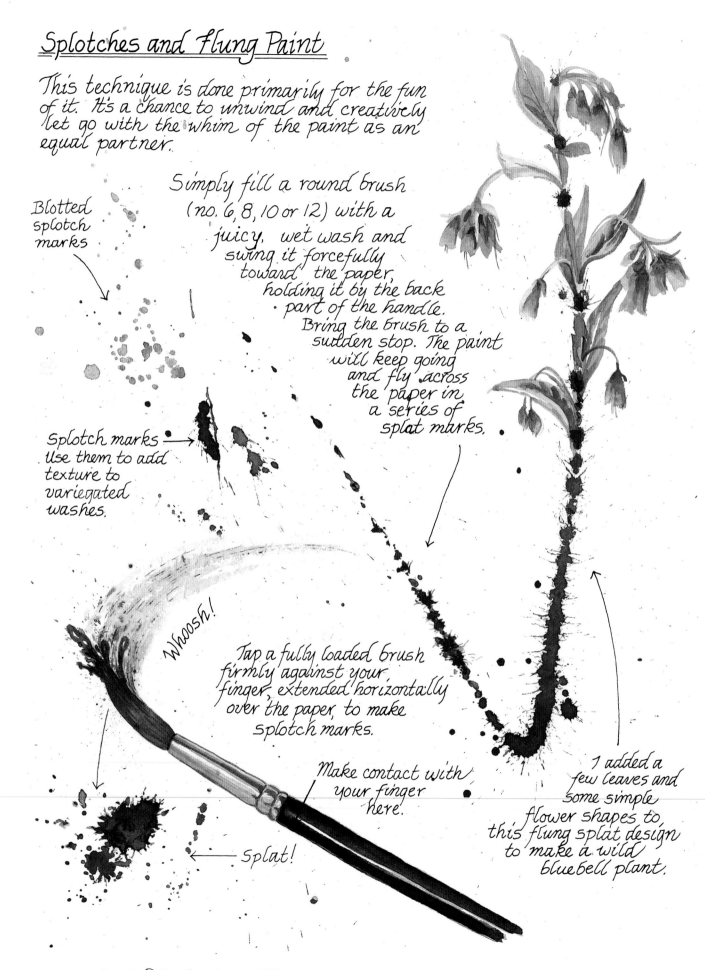

Blotted splotch marks

Simply fill a round brush (no. 6, 8, 10 or 12) with a juicy, wet wash and swing it forcefully toward the paper, holding it by the back part of the handle. Bring the brush to a sudden stop. The paint will keep going and fly across the paper in a series of splat marks.

Splotch marks. Use them to add texture to variegated washes.

Whoosh!

Tap a fully loaded brush firmly against your finger, extended horizontally over the paper, to make splotch marks.

Make contact with your finger here.

Splat!

I added a few leaves and some simple flower shapes to this flung splat design to make a wild bluebell plant.

In the lily painting below, spatter and splotch marks contribute most of the texture and add considerable interest. The flowers and leaves were painted first. Then the background was worked in around the florals.

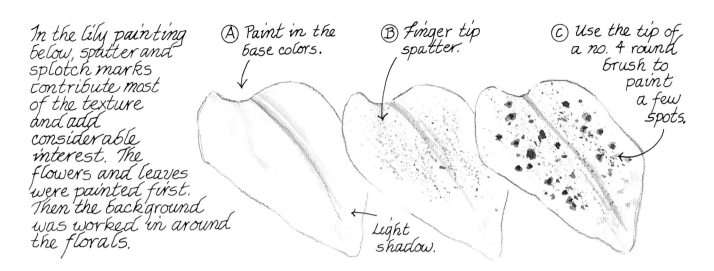

Ⓐ Paint in the base colors.

Ⓑ Finger tip spatter.

Ⓒ Use the tip of a no. 4 round brush to paint a few spots.

Light shadow.

The background is a basic flat **wa**sh of violet, toned down with a little warm yellow. Before the wash dries completely ----

---- more of the base color is flung on top.

The result is subtle splotch marks. (Cover the florals with paper cut-outs.)

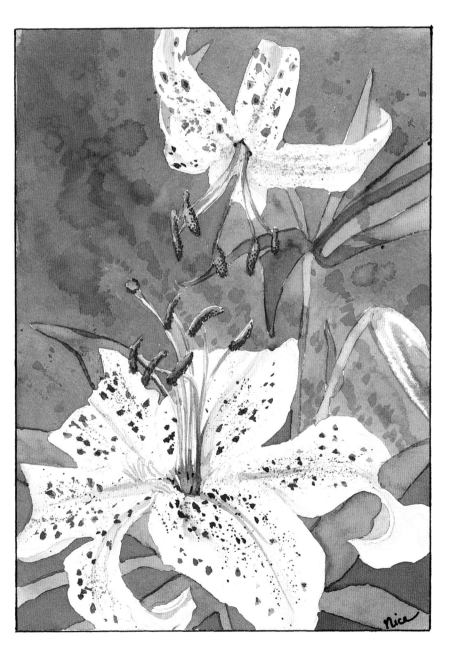

Nice

Stamping

Stamping is used most often to add interest to a background or to enhance the main subject. It is an easy way to incorporate a delicate or detailed design into a painting.

To make a good stamp, the object must be flat-sided and absorbent. Shiny, water-repellent surfaces like metal, glass, plastic and ceramics will not accept a coat of watercolor paint.

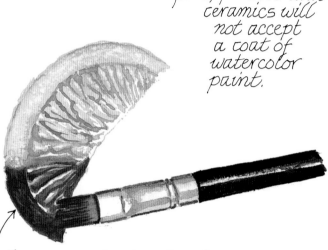

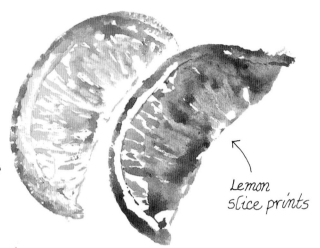

Lemon slice prints

The process is simple. Clean the "stamping object" to remove any dust, dirt, oil or, in the case of the lemon slice used above, lemon juice. (Plant sap or citric acid could affect the paint.)

Paint a heavy coating of watercolor paint on the side of the object to be printed, and while it's still wet, press it onto the paper. Test the process on scratch paper to see if the 1st or 2nd print comes out the clearest. It will vary according to the object.

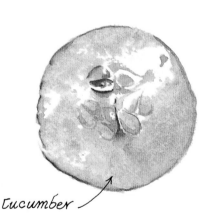

Cucumber

To make limp objects like lace print well, cover them with one or two sheets of paper toweling and rub the surface with your fingers. Make sure the object beneath does not move.

Under side of wild mushroom caps. (stem removed)

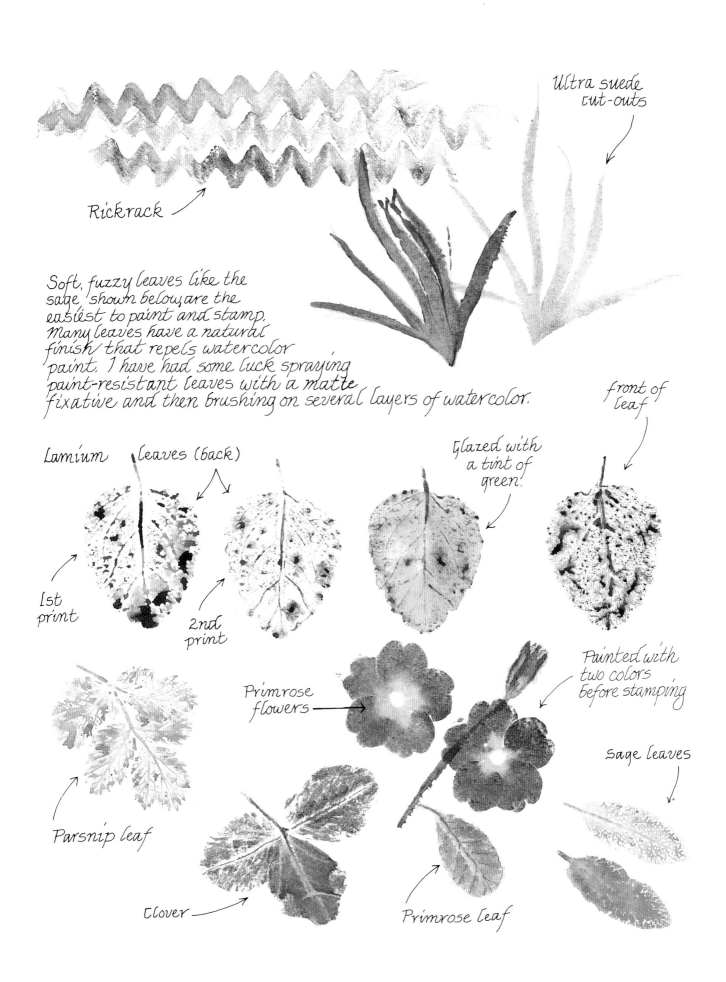

Rickrack

Ultra suede cut-outs

Soft, fuzzy leaves like the sage shown below, are the easiest to paint and stamp. Many leaves have a natural finish that repels watercolor paint. I have had some luck spraying paint-resistant leaves with a matte fixative and then brushing on several layers of watercolor.

Lamium leaves (back)

Glazed with a tint of green!

front of leaf

1st print

2nd print

Painted with two colors before stamping

Parsnip leaf

Primrose flowers

sage leaves

Clover

Primrose leaf

Creating a Repetitive Stamped Background

A plain and simple main subject can often be enhanced by setting it against a contrasting, patterned background. However, care must be taken that the background does not overwhelm the center of interest by being too bold.

Study the painting on the opposite page— OLD CERAMICS (8 x 10 inches). The dainty blue printed flowers add color and interest to the composition without stealing the show!

Here's how the print was made—

① A small four-petaled flower shape was cut out of 140lb. cold-press watercolor paper.

Actual stamp cut-out stained blue with paint.

② Paint the background with a very pale wash of Ultramarine Blue and Thalo Blue. Let dry. Draw some vertical guide lines, just a little wider than your flower shape.

1st

2nd

③ Paint the flower cut-out with Ultramarine Blue and stamp it between two of the pencil lines. Repaint the stamp and print it in the adjacent column, just below where the first print was made. Continue painting and printing, staggering the design. When the prints are dry, use a round brush (no. 4) to paint a yellow ring and a cool red dot in the flower centers.

④ Finish the repetitive design by adding a tiny, green brush tip leaf between each flower petal. A row of brush tip dots will cover up each of the pencil guide lines.

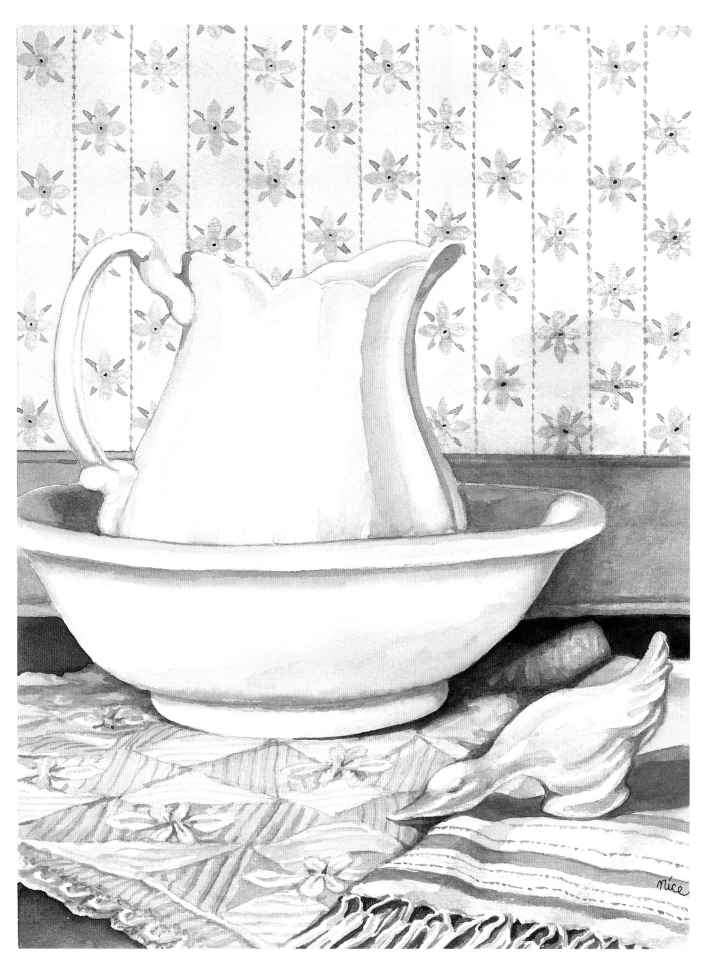

nice

Stamped Back-Ground Ideas

These mock wallpaper prints were stamped from common house and garden items.

Printed from sage leaves.

Printed with a net-covered sponge.

Printed with a primrose and wild rose leaves. Details were added with a round brush.

String and pencil eraser prints.

Fern prints accented with wet-on-wet spatter.

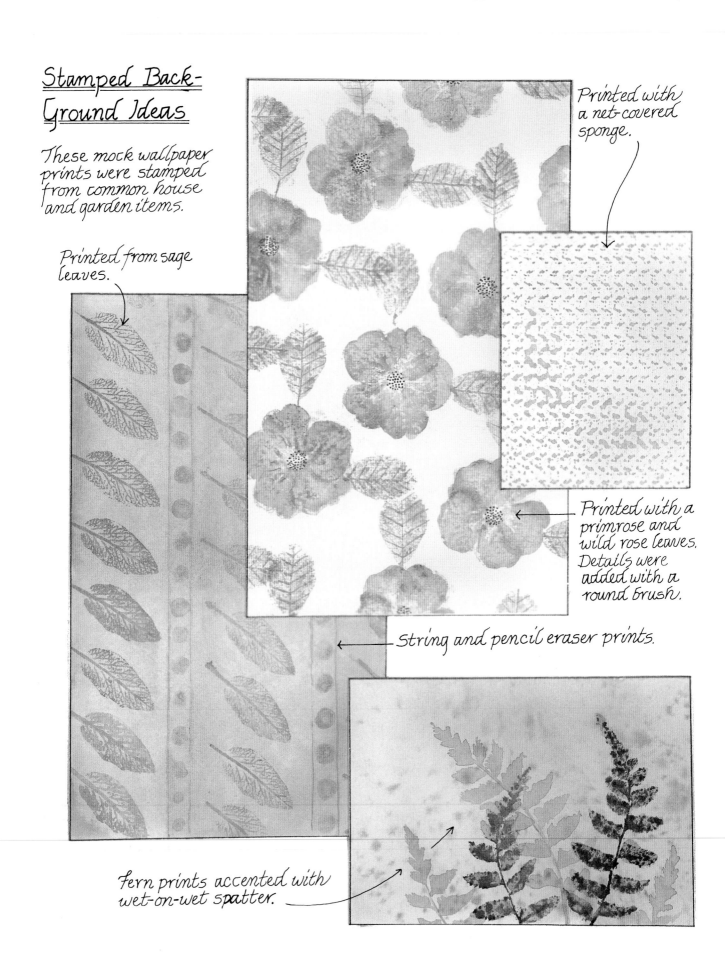

Stamping as a Drawing Aid

Trying to duplicate the details of complicated subjects like lace, ferns, etc. can be both difficult and time-consuming. The results often look a bit stiff and contrived. An alternative to drawing is to stamp the object on the paper, providing it's flat and absorbent enough, then fill in the details with a wash of watercolor.

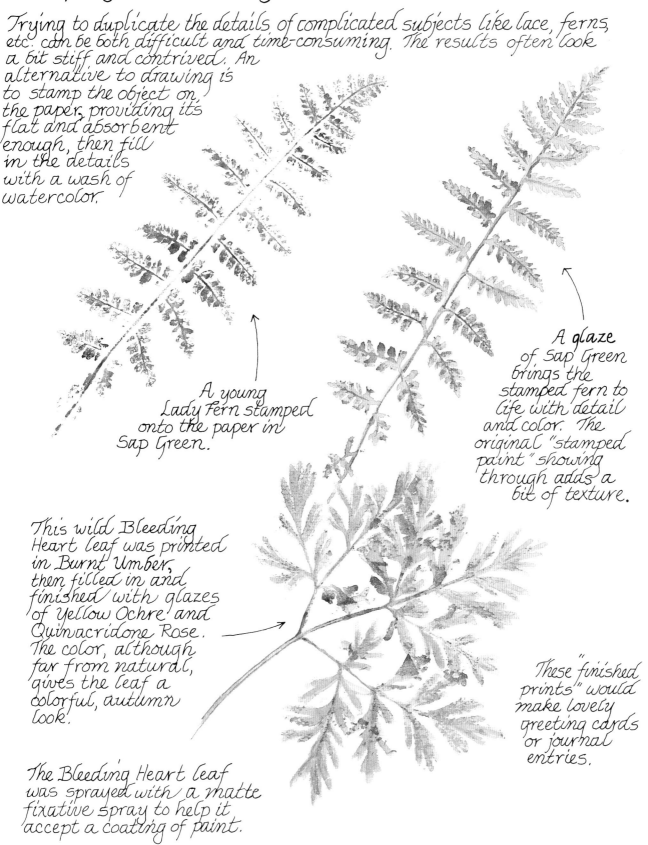

A young Lady Fern stamped onto the paper in Sap Green.

A glaze of Sap Green brings the stamped fern to life with detail and color. The original "stamped paint" showing through adds a bit of texture.

This wild Bleeding Heart leaf was printed in Burnt Umber, then filled in and finished with glazes of Yellow Ochre and Quinacridone Rose. The color, although far from natural, gives the leaf a colorful, autumn look.

These "finished prints" would make lovely greeting cards or journal entries.

The Bleeding Heart leaf was sprayed with a matte fixative spray to help it accept a coating of paint.

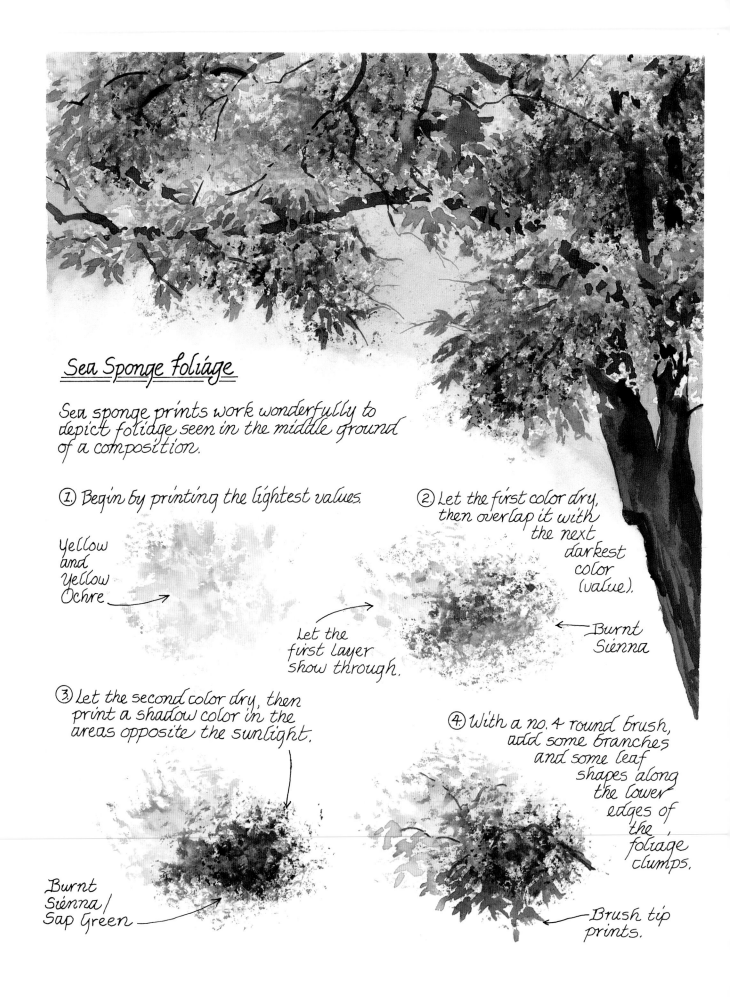

Sea Sponge Foliage

Sea sponge prints work wonderfully to depict foliage seen in the middle ground of a composition.

① Begin by printing the lightest values.

Yellow and Yellow Ochre →

Let the first layer show through.

② Let the first color dry, then overlap it with the next darkest color (value).

← Burnt Sienna

③ Let the second color dry, then print a shadow color in the areas opposite the sunlight.

Burnt Sienna / Sap Green →

④ With a no. 4 round brush, add some branches and some leaf shapes along the lower edges of the foliage clumps.

Brush tip prints.

Sponging

Sponging is a quick and simple way to give a soft, thick, layered appearance to an area of your watercolor painting. This texturing effect can be achieved by dipping a sponge or other soft, absorbent material into a prepared wash puddle on your palette, blotting it lightly on a paper towel and pressing it gently to the watercolor paper. (Make firm contact, but don't press so hard that the raised areas of the sponge are compressed.) Dry, stiff sponges need to be softened in water and wrung out until barely damp, to make them ready for use.

Sea sponge dipped into a wash puddle of Burnt Sienna paint.

Sponge print

Too wet -- no texture!

rag

Two-layer sponge print -- very fluffy!

Gauze print

Cotton ball printed numerous times.

Sea sponge dragged across paper surface.

Coarse sea sponge print.

Fine grain sea sponge print.

Manufactured kitchen sponge prints. The holes leave round shaped **open** areas that lend themselves well in the creation of pebbles and soil textures.

Making Kitchen Sponge Pebbles

(A) Start with a clean kitchen (manufactured) sponge. 2½ by 4 inches is a good size for this project. Smaller pieces are OK.

(B) Soften the sponge by dipping it in clean water. Squeeze out the extra moisture.

(C) Make a practice print~

Paint the surface of the sponge or "wipe up" paint from the surface of the palette.

(D) Press the sponge, painted surface down, firmly to the paper. Keep the pressure even, compressing the sponge half way down. If the paint is heavy, blot it once on a paper towel before printing.

Perfect print →

The sponge was too wet — holes filled in.

Finger print - too much pressure in one spot.

The print is faint, not enough paint on the surface of the sponge.

a.

b.

c.

Begin the pebble beach practice project with a pencil sketch of a seagull as shown. Add a horizon line just below its belly. A post card size piece of water-color paper will do.

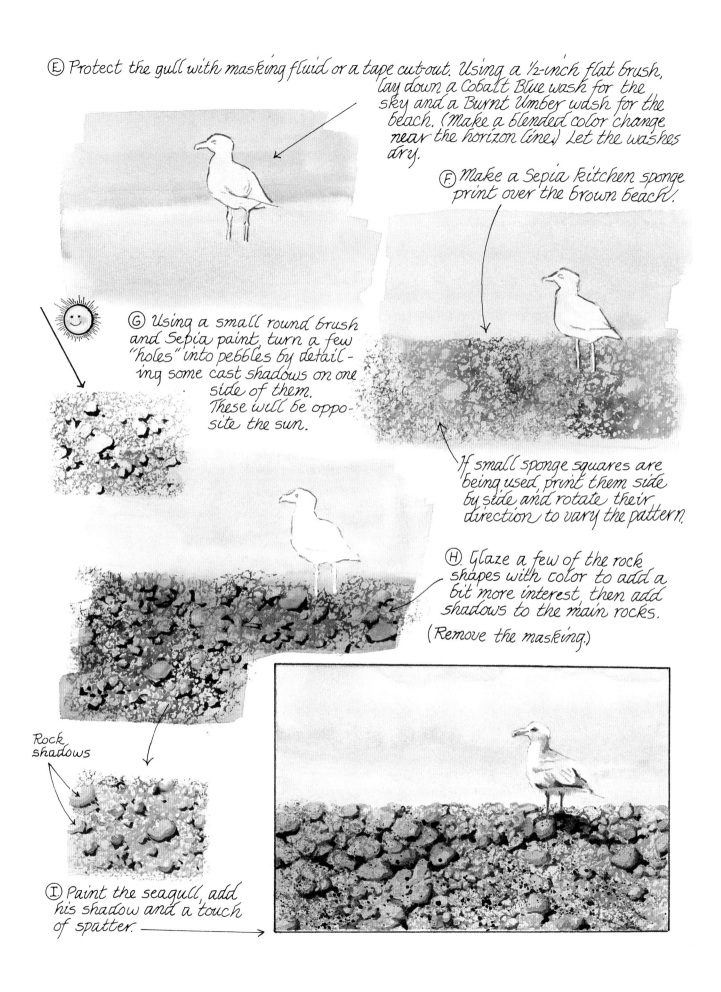

E Protect the gull with masking fluid or a tape cut-out. Using a ½-inch flat brush, lay down a Cobalt Blue wash for the sky and a Burnt Umber wash for the beach. (Make a blended color change near the horizon line.) Let the washes dry.

F Make a Sepia kitchen sponge print over the brown beach!

G Using a small round brush and Sepia paint, turn a few "holes" into pebbles by detailing some cast shadows on one side of them.
These will be opposite the sun.

If small sponge squares are being used, print them side by side and rotate their direction to vary the pattern.

H Glaze a few of the rock shapes with color to add a bit more interest, then add shadows to the main rocks.

(Remove the masking.)

Rock shadows

I Paint the seagull, add his shadow and a touch of spatter.

CHAPTER SEVEN

Going Wild with Flow-Altering Techniques

Water is an element of motion. It oozes, drips, slides,

meanders, tumbles, leaps and plunges with the slightest encouragement. Furthermore, it's very social, gathering up bits of this and that and pulling them along on its exploratory journey. The bigger the gathering (puddle) and the more slanted the terrain (paper), the more rambunctious the playful water becomes. Recognizing the restless nature of watercolor, the artist can manipulate the flow of the paint to create wonderful textural effects, not possible with many other mediums. To understand how to control the ebb and flow of pigment-filled water, try thinking like a wash puddle. You've just been brushed over a damp paper surface. Sensing that there is a little resistance, you spread out a bit. You'd like to frolic down a steep hill pulling your rose pigment partners along, but the only downward place to go is a slow seeping movement into the moisture-laden fibers of the paper. All is orderly and quiet, then whoosh! A marauding puddle of Ultramarine Blue breaches your eastern perimeter. It's wet, wild and exciting. As it moves in, it mingles with your remaining moisture and gathers up the sleepy rose pigment. Like an impromptu celebration, the rose and blue pigments partner up to dance in whirls of liquid violet. Gradually the excitement lessens and the partners move to the edge of the dance floor to rest. It becomes crowded there. Slowed with the fatigue of drying, you again settle slowly downward. You leave behind a gathering of pigment, too thick to follow in your wake. The result, a lacy bloom pattern and a color change where the original flow of settling paint was altered. While often thought of as a disaster, the "bloom" is a flow-altering technique that, when under the control of the artist, creates striking and desirable texture. As seen on the opposite page, there are numerous other techniques. This chapter will explain how to master the most common ones. Experiment, have fun, and don't be too upset if the water gets just a little carried away. After all, flowing is the essence of its nature.

I call this wild piece VIOLET TEXTURESCAPE. It was a really fun way to loosen up and experiment with various flow-altering effects.

Spray mister

Straw blowing

Salt

Alcohol drop

Bloom (water drops)

Blotting

Rock salt

Bruising

Impressed sand

Blotting, Scrubbing and Lifting

Lifting is the removal of pigment from a previously painted area. This is most easily accomplished while the wash is still fresh and wet.

Blotting is the process of pressing an absorbent material (cloth, sponge, paper towel, tissue, sable brush, etc.) into a freshly laid wash or a dry wash that has been remoistened and scrubbed, to soak up and lift away pigment.

This wash was blotted with a folded paper towel. The surface of the towel was rubbed gently.

Press down gently.

Blotting procedure ~

① Begin by laying down a damp surface wash. Washes brushed over a dry surface will lift also, but bind to the surface much faster. In either case, avoid overworking the paint down into the fibers.

② Press the absorbent material down into the moist paint and lift straight up. 7 used a crumpled facial tissue in the illustration above.

③ The fluffy pattern left by the crumpled tissue makes lovely, wispy clouds, and is ideal for texturing backgrounds and tangled underbrush areas.

The center of this leaf was lifted out while the Sap Green wash was still moist. 7 used a no. 6 round sable brush, draw the brush from the stem toward the leaf tip in one long stroke. The brush was moist, but well blotted and very thirsty. The leaf was almost dry when it was time to do the tiny side veins. 7 loosened the pigment by working the tip of the damp round brush back and forth over each vein line. A tissue was used to gently dab away the loosened paint.

To remove accidental paint marks, add a drop of water to the paint and work it gently with a brush to loosen and float the pigment. Then blot.

Effective paint lifting from a dry painted surface requires a generous layer of paint to work with. The first layer of paint to settle on the paper surface will sink into the fibers and cling tenaciously. It will be very difficult to remove. In heavier washes or built-up paint layers, a good amount of pigment can be loosened by scrubbing a stiff, moist brush over the surface. Use a tissue to blot up the pigment as it comes free.

Thin, dry wash... scrubbing loosens few pigment particles.

Heavy dry wash... scrubbing will loosen quite a few pigment particles.

Dry, layered wash... a damp, stiff brush can scrub its way through the layers. Clean the brush often.

The results of scrubbing and lifting are seen above. Note how they vary according to the wash thicknesses.

Soft round brush.

Stiff, synthetic flat brush.

Lifting out highlights ~

Ⓐ Lay down a round Lemon Yellow wash and let dry.

Ⓑ Layer on a yellow-green mix (Lemon Yellow mixed with Sap Green). Daub a little straight Sap Green into the wet wash and let it flow. Allow the paint to dry.

Caution: Over-vigorous scrubbing will ruin water color paper.

Ⓒ Use a stiff, moist brush to scrub and loosen the pigment in the highlight area. Blot the pigment away with a tissue. Glaze in some shadows and details.

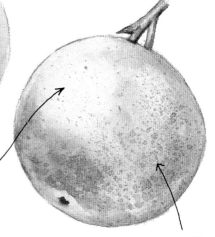

Spatter

Water Drops and Spray Bottles

Water drops introduced into a moist wash will most likely result in small, circular blooms with frilly, uneven edges. They have a softer appearance than the designs produced by salt crystal reactions.

Water drops in a wet-on-wet wash.

The examples directly below and in the upper right-hand corner were produced by filling a no. 6 round brush with water and tapping the handle vigorously against an outstretched finger. Water drops were flung into the wet wash below.

Water drops in a wet stage one wash.

Water drops in a stage two wash.

Water drops in a wash that is almost stage three.

Water drops in an early stage three wash.

The washes below were all stage two when they were sprayed with various water spray bottles.

Applied with a fine spray mister.

Applied with a nozzle from an empty glass cleaner spray bottle (well rinsed). This produced both fine and medium droplets.

Medium water droplets from a spray bottle.

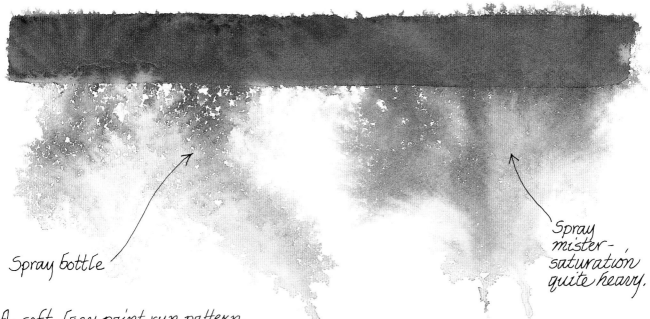

Spray bottle

Spray mister-saturation quite heavy.

A soft, lacy paint run pattern can be produced by laying down a very wet, dry-surface wash and immediately spraying the edge of the wash lightly with water. Tilt the paper slightly in the direction of the water spray to encourage the paint to flow. The pigment should flow from water drop to water drop, charging each droplet with a quantity of colored particles. If the paint refuses to run, spray it again, but use caution. Over saturation of the paper will spread the paint, minus the lacy design.

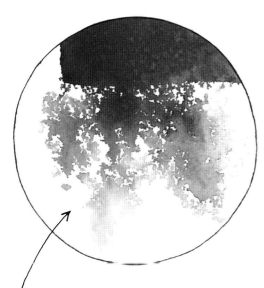

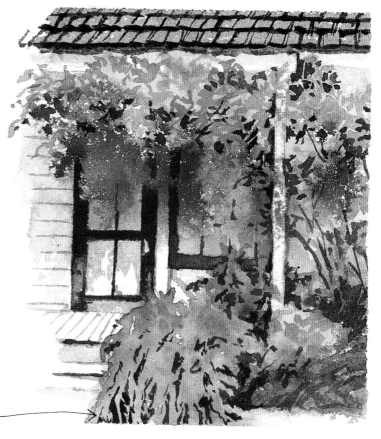

Enlargement of the water spray induced flow used to suggest the wisteria vine in the porch painting to the right.

Details added with a no. 4 round brush.

Thrown Trees and Shrubs

Foliage created from thrown paint is unpredictable, messy and fun.

Preparation: Tape the watercolor paper down along the edges to prevent curling. Spread newspapers over the areas where you don't want paint. Put on an apron or paint shirt. Mix up two or three cream-thick paint puddles on your palette. Make them generous. You won't have time to stop and mix up more.

① Begin by flinging the premixed colors into the foliage areas of your paper. Use a no. 10 sable round brush or a soft hair mop or wash brush. Fully load the brush. Hold the handle near the end and swing it toward the paper with vigor. Snap it to a sudden stop several inches above the work surface. Paint drops should fly onto paper. Splat! If the results are sparse, make the paint mix wetter and your hand action wilder.

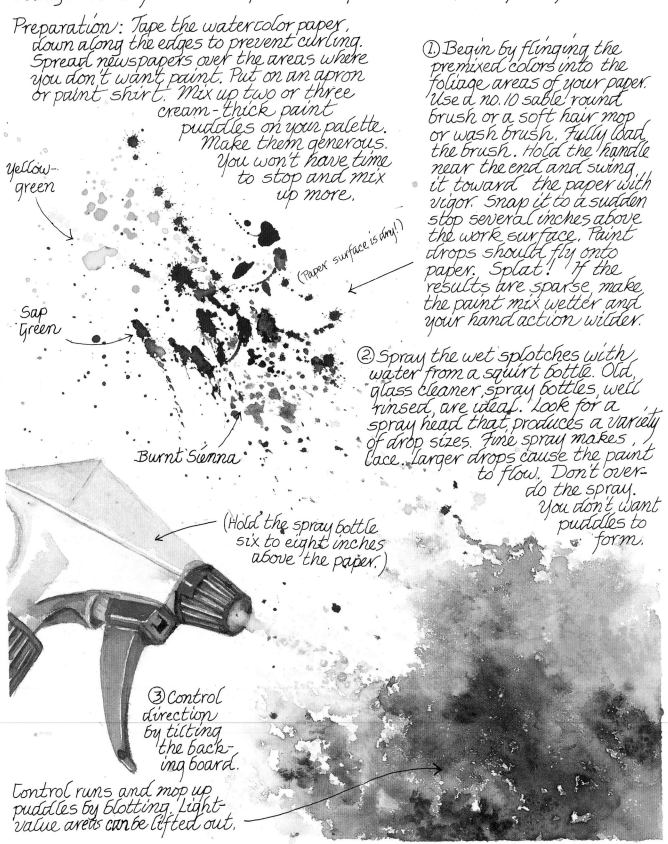

Yellow-green

Sap Green

Burnt Sienna

(Paper surface is dry!)

② Spray the wet splotches with water from a squirt bottle. Old, glass cleaner, spray bottles, well rinsed, are ideal. Look for a spray head that produces a variety of drop sizes. Fine spray makes lace. Larger drops cause the paint to flow. Don't over-do the spray. You don't want puddles to form.

(Hold the spray bottle six to eight inches above the paper.)

③ Control direction by tilting the back-ing board.

Control runs and mop up puddles by blotting. Light-value areas can be lifted out.

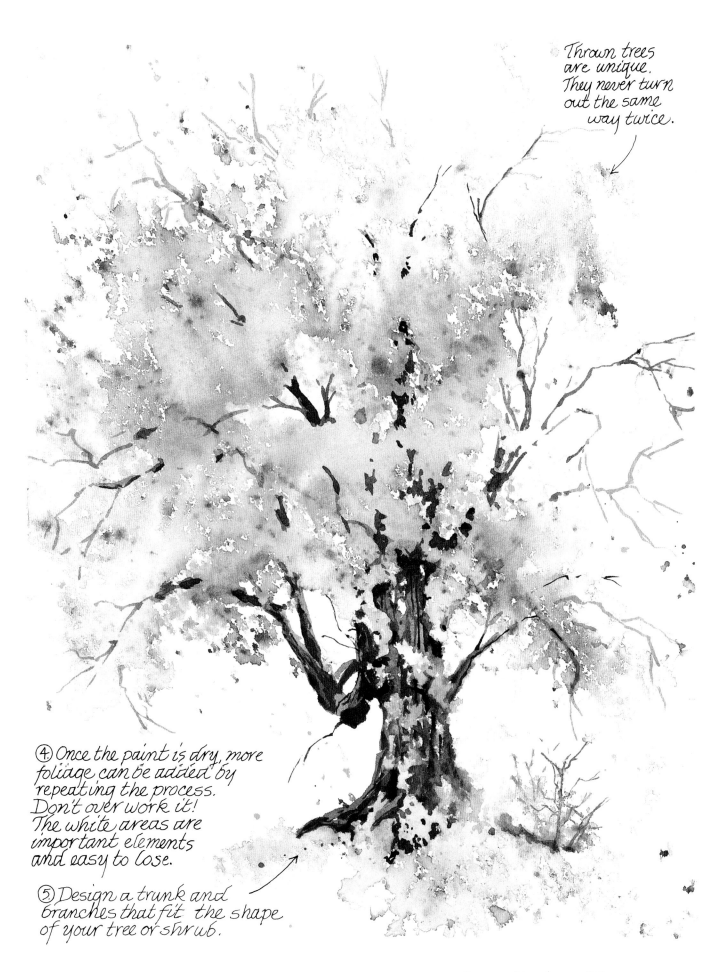

Thrown trees
are unique.
They never turn
out the same
way twice.

④ Once the paint is dry, more
foliage can be added by
repeating the process.
Don't over work it!
The white areas are
important elements
and easy to lose.

⑤ Design a trunk and
branches that fit the shape
of your tree or shrub.

Straw-Blown Roots

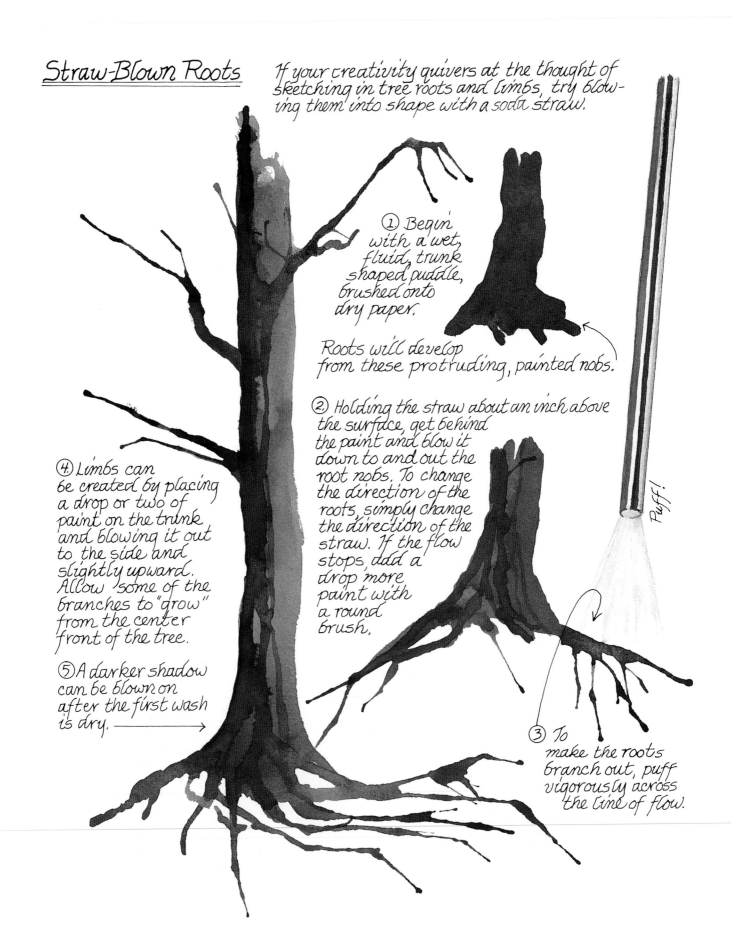

If your creativity quivers at the thought of sketching in tree roots and limbs, try blowing them into shape with a soda straw.

① Begin with a wet, fluid, trunk shaped puddle, brushed onto dry paper.

Roots will develop from these protruding, painted nobs.

② Holding the straw about an inch above the surface, get behind the paint and blow it down to and out the root nobs. To change the direction of the roots, simply change the direction of the straw. If the flow stops, add a drop more paint with a round brush.

Puff!

③ To make the roots branch out, puff vigorously across the line of flow.

④ Limbs can be created by placing a drop or two of paint on the trunk and blowing it out to the side and slightly upward. Allow some of the branches to "grow" from the center front of the tree.

⑤ A darker shadow can be blown on after the first wash is dry. ⟶

Straw-blown paint also makes
wonderful brush, brambles and
vines.

In the Garden Gate
painting shown below,
straw-blown vines are
climbing the fence. Other
flow-altering techniques
used include water drops in
the background and salt in
the foreground.

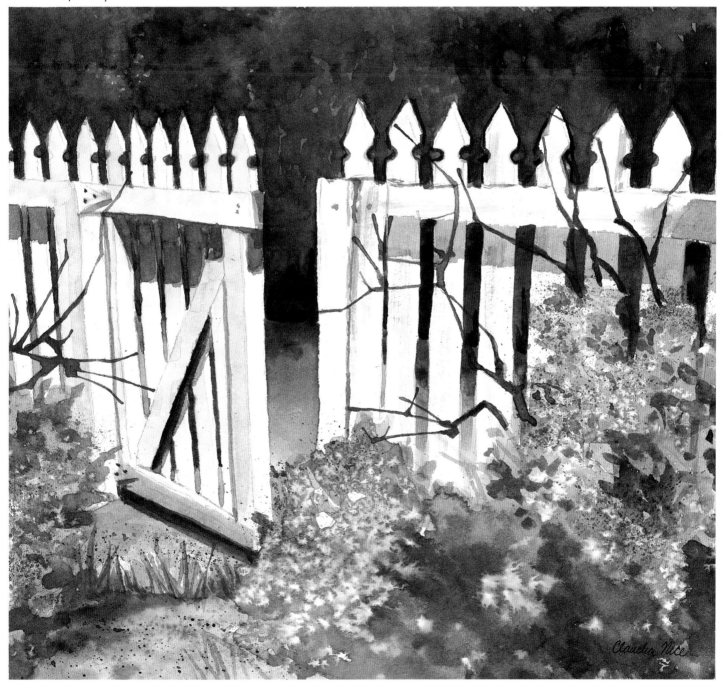

Bruising and Scraping

In these two techniques, tools are used to disturb the pigment in various stages of the drying process. Most of the tools listed below you probably already have. The broad ones work best for scraping and the bluntly pointed ones are great for bruising.

<u>Bruising</u>~ comb stick stylus key tweezers

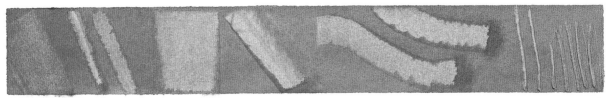

<u>Scraping</u>~ Brush Credit cards cut at mini key
 handle **two different widths** chisel

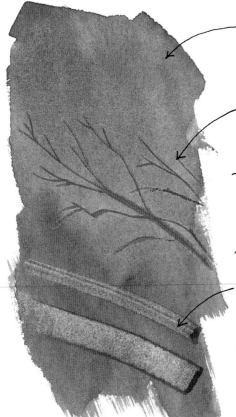

The difference between the bruising and scraping procedure is not so much the tool, but when the tool is applied. Both techniques begin with a damp surface wash.

Bruising (sometimes referred to as scarring) takes place while the wash is still very wet. Stage one into early stage two provides the best results. During this early period the paint is not yet clinging to the fibers and is very mobile. The tool compresses the paper and breaks the delicate barrier between the paint and the moisture-filled fibers beneath. The pigment rushes into the bruised area, forming dark lines.

Scraping takes place during late **stage** two when the pigment begins to settle into the fibers, but the paint surface still has a damp sheen. Pulling a blunt tool through the wash at this time will squeeze a good amount of pigment out of the paper fibers and shove it ahead and to the sides, like a bulldozer moving dirt.

Shown below are some practical uses for bruising and scraping techniques.

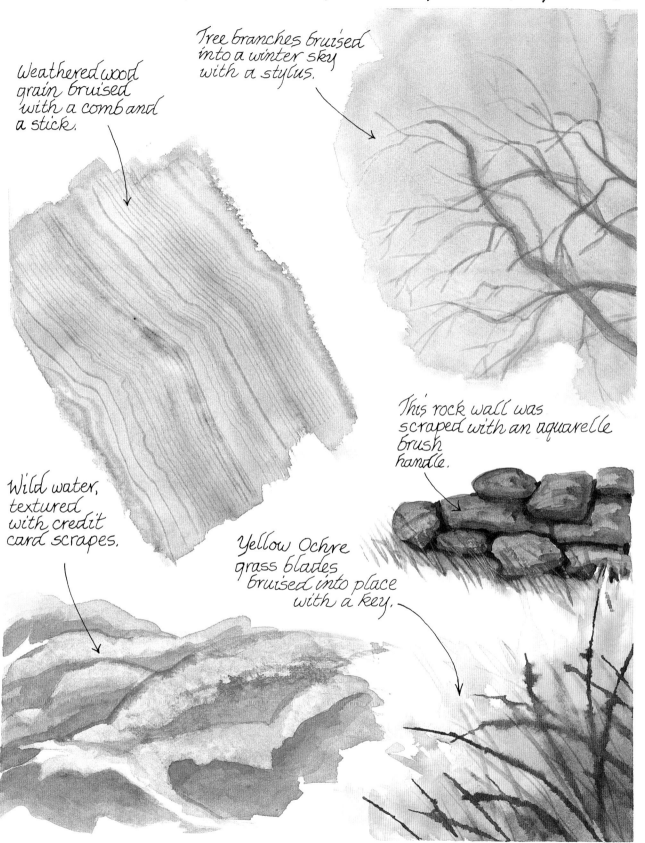

Weathered wood grain bruised with a comb and a stick.

Tree branches bruised into a winter sky with a stylus.

This rock wall was scraped with an aquarelle brush handle.

Wild water, textured with credit card scrapes.

Yellow Ochre grass blades bruised into place with a key.

Creating Impressed Textures

A puddle of liquid has the tendency to cling to anything that is placed upon its surface. If you float a toothpick in a large wash puddle and lift it slowly by one end, you will see the liquid rise up and try to hold on. It's caused by surface tension, one of the forces in nature. If the toothpick remains undisturbed in the wash puddle until the liquid dries up, the pigment that gathered beneath it and along the sides due to surface tension will remain as a dark imprint. This differs from stamping in the fact that the toothpick was not pre-painted.

Surface tension

Toothpick impressions

① Start with a very moist, damp surface wash. Daub the wash on in short strokes so plenty of liquid is left on the paper but no actual puddles.

② Place the chosen objects into the wet wash and pat them down with a soft brush, or weight them down so they make good contact with the paper surface.

③ Do not disturb the impressed items until the paint underneath is completely dry.

Dog hair patted down into the paint

Razor blade impression

A key impression

Impressed rubber bands

Leaf Impressions

Leaves make lovely impressed designs. I like to use them as "fillers" in close up floral scenes like the bit of meadow painted below.

Begin with a damp surface wash. It should be very moist, but not gathered in puddles.

While it is still in stage one, lay a leaf in the wash and pat it down with a soft brush. If it springs back up, weight it down with a couple pebbles or paint tubes.

Don't lift the leaf until it is completely dry.

Young, limp leaves are the easiest to work with. Newly-sprouted, tender dandelion foliage always works well for me.

Raspberry leaf impression

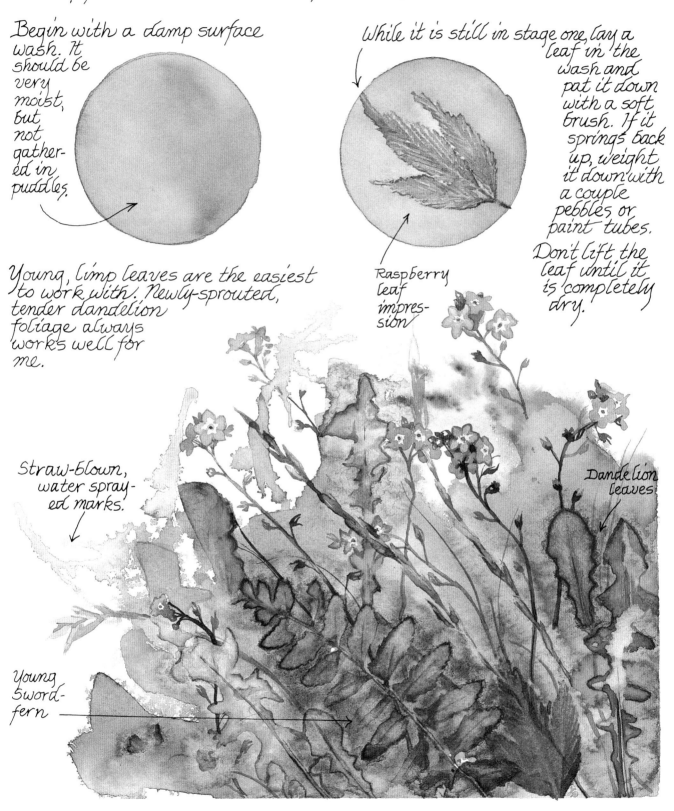

Straw-blown, water sprayed marks.

Dandelion leaves

Young Sword-fern

Impressed Plastic Wrap

Wrinkled plastic wrap laid into a wet wash and secured into place until the wash beneath is dry will produce dark, irregular shapes. These shapes can represent a lot of different textures ranging from foliage to cobble stones. It all depends on the colors used, the way in which the plastic wrap is crinkled and the whim of the drying paint.

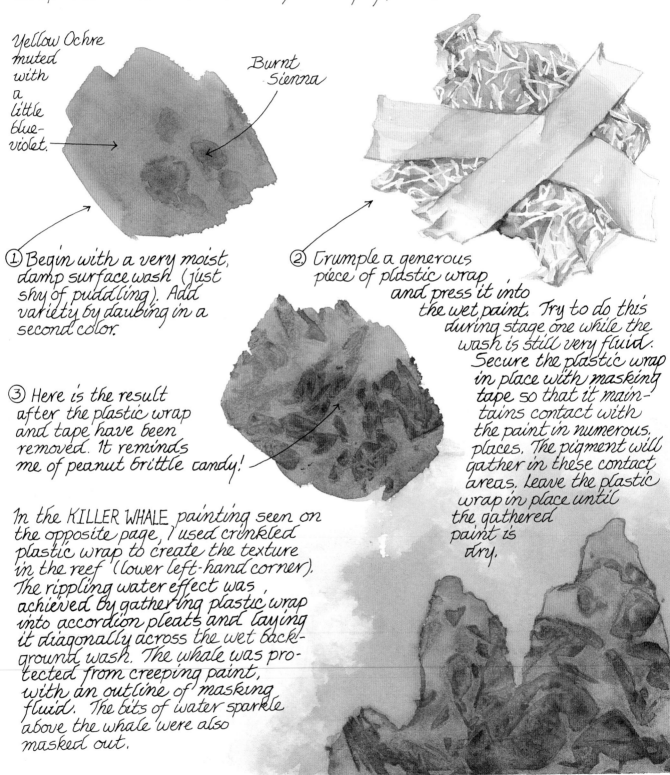

Yellow Ochre muted with a little blue-violet.

Burnt Sienna

① Begin with a very moist, damp surface wash (just shy of puddling). Add variety by daubing in a second color.

② Crumple a generous piece of plastic wrap and press it into the wet paint. Try to do this during stage one while the wash is still very fluid. Secure the plastic wrap in place with masking tape so that it maintains contact with the paint in numerous places. The pigment will gather in these contact areas. Leave the plastic wrap in place until the gathered paint is dry.

③ Here is the result after the plastic wrap and tape have been removed. It reminds me of peanut brittle candy!

In the KILLER WHALE painting seen on the opposite page, I used crinkled plastic wrap to create the texture in the reef (lower left-hand corner). The rippling water effect was achieved by gathering plastic wrap into accordion pleats and laying it diagonally across the wet background wash. The whale was protected from creeping paint with an outline of masking fluid. The bits of water sparkle above the whale were also masked out.

Depicting Rust With Impressed Sand

This impressed texture is really fun and surprisingly effective. There are a few extra steps in the process, so study the steps shown below carefully.

① Start with a dry surface wash of Payne's Gray. This represents the color of the metal under the rust. Let the wash dry.

Beach or river sand.

The base wash should not be darker than this.

② Add a medium-dark glaze of Burnt Sienna. Allow the wash to be fairly wet. Don't over work it. Daub in a little Payne's Gray or blue-green for variety.

③ Immediately sprinkle in some sand. Don't let it pile up.

④ Spatter in some water drops for additional texture. Don't over do the spatter. Avoid creating puddles. Allow the wash and water drops to dry slowly and completely.

⑤ Brush away the sand.

⑥ Develop nails and other contours by adding shadows and lifting out or scraping in highlights.

Opposite page – RUSTY RING IN WEATHERED WOOD – (8x10) – The rust was sand impressed.

The Salt Technique

Although it's uncertain how salt residue will affect paper and paint long range, texturing with salt has always been popular with watercolorists. When all goes well, the salt crystals melt, pushing the pigment back and producing pale, lacy-edged spots resembling snow flakes.

(Pen and ink detailing on trees and snowman)

Preparation: To assure that the salt crystals are very dry and thirsty, bake them in the oven or place them on a paper towel in the microwave oven for a minute, on high. Let them cool and store them in a sealed salt shaker. I keep my salt shaker in a Ziploc lunch bag.

① Start with a damp surface wash. While it is still shiny wet (stage two), sprinkle in some salt crystals. Keep them spread apart.

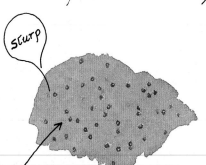

Slurp

② The thirsty salt will draw moisture and pigment to it and turn dark. Given enough moisture, the salt will start to melt.

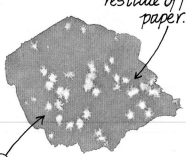

When dry, brush salt residue off the paper.

③ The saline flowing outward reacts with the paint and pushes it back. Tiny snow-flake "blooms" appear.

Varied Salt Reactions and What Caused Them

Normal reaction for comparison.

Wash too dry—(entering stage three).

Wet wash—very fluid (stage one).

The wash was over worked into the paper—little movement.

Over salted—little room to flow.

Sprayed with water mister after salt was applied.

Sprayed with water mister and paper was tilted.

Water was spattered onto moist wash and applied salt.

Wet wash and mixed pigment color - Indigo.

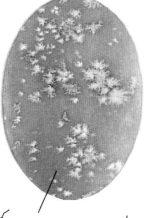

Coarse-grained salt.

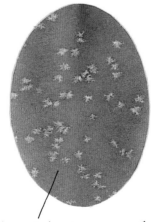

Hair dryer used—salt action stopped.

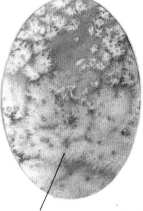

Uneven moisture in wash.

Rock Salt

Rock salt introduced into a stage two settling wash produces large, pale, flower-like blooms. It is handled in much the same way as the smaller salt crystals with one exception --- because of their size, rock salt granules must be dipped in water to start them melting before they are placed in the wash. Tweezers make them easier to handle.

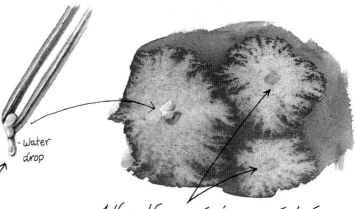

- water drop

When the wash is completely dry the salt is removed.

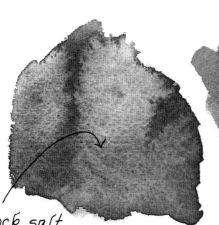

Rock salt crystals introduced into a very wet, stage one wash. Saline flow was uncontrolled.

Rock salt crystals in a stage two wash (Typical reaction).

Colored rock salt blooms can be produced by layering one wash over a second *dry* wash. In this case, yellow was laid first, allowed to dry and Burnt Umber was layered on top. Salt crystals were added as the brown wash settled into stage two.

Rock salt blooms make wonderful, lacy background designs, sea creatures in underwater scapes, floral blossoms, moss, lichens and tree bark fungus. In addition, they're just plain fun!

A daisy bed of rock salt blooms. The details were glazed on using a no. 4 round detail brush.

This treefrog study is full of salt texturing. It would make a fun practice piece. The main colors I used on it are listed to the right.

Frog green: Permanent Green / Cadmium Yellow.
Frog browns: Various mixtures of Sepia, Burnt Sienna and Cadmium Yellow.
Mossy rock: Top - Sepia Middle - Burnt Sienna Moss - Sap Green
I also used some "dirty palette colors" here and there.

Glazing

Rock salt placed in stage one wash.

The rock colors were blended into each other using charging techniques.

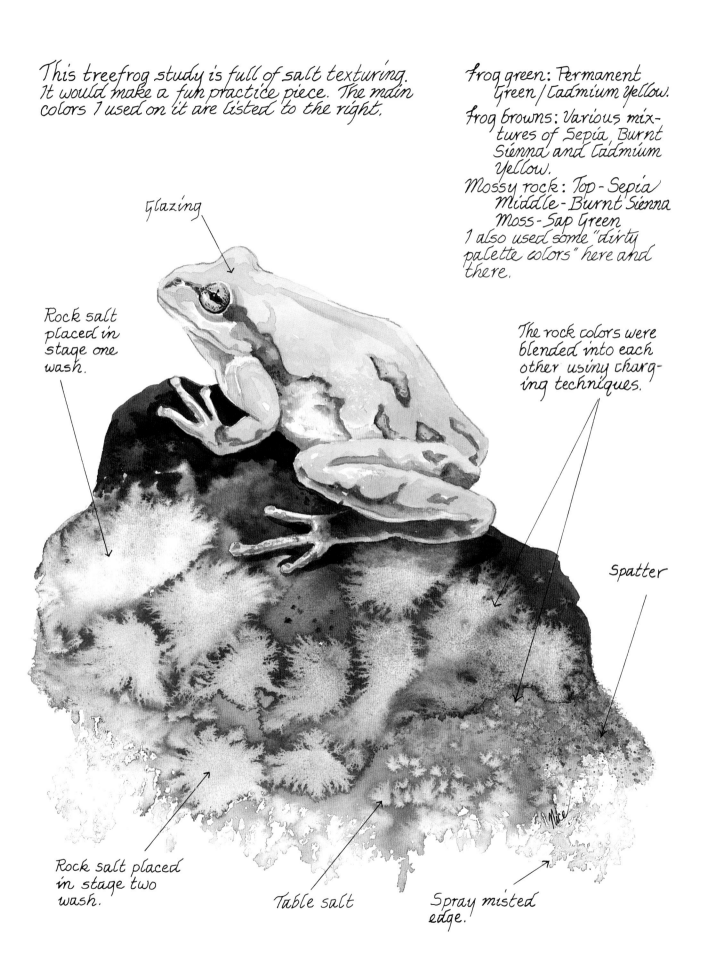

Spatter

Rock salt placed in stage two wash.

Table salt

Spray misted edge.

Alcohol Texturing

When alcohol drops are dripped or spattered into a wash that is beginning to settle, rings with dark centers are formed.

I use Isopropyl alcohol and a synthetic hair round brush to apply it.

If the wash has been over-brushed or has become too dry (entering stage three) the design pattern will be faint or fail to appear at all.

In the painting VARIEGATED GUPPIES (8 x 10 inches) seen on the opposite page, I used alcohol drops to create the bubbles in the underwater scape. Alcohol drops, spatter and line scribbles work well to texture backgrounds, textiles, weathered wood, rocks, granite-**ware** pots, lichen, leaf blemishes and tree bark.

A round brush, dipped in alcohol, blotted lightly and brushed through a fresh wash will result in pale, dark-edged lines with irregular perimeters. This example reminds me of marble.

Alcohol lines (Batik effect)

Polynesian tapa cloth reproduction

An interesting dark bruised effect can be created by brushing over the wash and alcohol design areas with a clean, moist brush while the wash is still in stage two. The alcohol-roughened paper will attract and trap extra pigment.

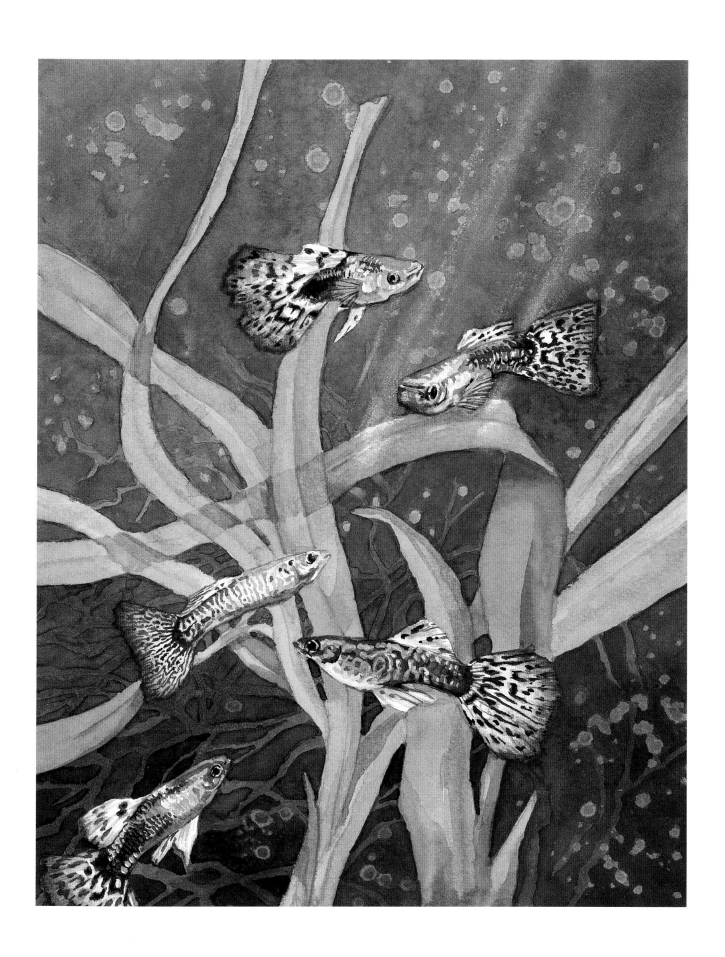

Index

A

Alcohol drop technique, 45, 105, 126–127

B

Back run, 6, 46, 68
Backing board, 19
Bead, 6
Bloom, 6, 72, 75, 104–105
Blot marks, 45, 72, 73, 75
Blotting, 6, 105, 106
Bruising technique, 6, 17, 105, 114–115
Brush strokes, 16–17
Brushes
 cleaning, 15
 loading, 15
 maintenance of, 17
 types of, 14
Butterfly glazing project, 87

C

Charging, 6
Chroma, 7
Clouds, 50–51
Colors
 analogous, 6
 basic concepts of, 24–25
 blending, 44, 76
 complementary, 6
 cool, 25
 granulating, 23
 intensity of, 7
 landscape, 27
 mixing, 26–35, 76
 opaque, 22
 optical change of, 7, 76, 78–79
 primary, 24, 29
 secondary, 24
 staining, 23
 tertiary, 24
 transparent, 22
 triad of, 34–35
 value of, 7
 warm, 25
 See also Glazing and Layering, Washes

D

Detail work, 39
Drybrushing, 6, 42–43, 73

E

Erasers, 19

F

Fence, stone, 36–37
Fleshtone mix, 47
Flow-altering techniques, 6, 45, 104–127
Foliage, 109, 110–113, 117

G

Glass, depicting, 82
Glazing and layering, 6, 76–87
 effects of, 78–79
 projects, 87
 step-by-step, 80–81
Granulation, 6
Grass, 39, 41, 115

H

Hair dryer, portable, 19
Highlights, 40, 107
Hue, 6

I

Impressed texture, 7, 45, 105, 116–21

L

Layering and glazing, 7, 76–87
Leaves, 74–75, 95, 106, 117
Lifting technique, 7, 106–107
Lines, 39

M

Masking, 7, 19, 36, 52–57
Masking fluid, 19

O

Optical color change, 7, 76, 78–79

P

Paint, 20-23
 flung, technique, 92–93, 110–111
 See also Colors
Palette
 arrangement, 27
 limited, 34–35
 setting up, 26–27
 types, 18
Pansy, 80–81
Paper, watercolor
 presentation, 11
sizing, 12
 stretching, 13
 taping, 12
 texture, 10
 weight, 11
Pebble beach project, 102–103
Pigment, 7
Plastic wrap impression, 118–119
Portrait, 47

R

Razor blades, 19
Razor scraping, 36–37, 40, 83
Rock wall, 115
Rose, 87
Rubber cement pick-up square, 19
Rust texture, 120–121

S

Salt technique, 45, 105, 122–125
Sand technique, 105, 120–121
Scrapers, 17, 19
Scraping technique, 7, 17, 19, 36–37, 40, 114–115
Scrubbing technique, 7, 64, 106–107
Seafoam, 53
Seascape project, 34–35
Shadows, 30, 39, 79, 86
Shrubs, 87, 110–113
Sky, 52, 66
Spatter technique, 7, 72, 88–89, 90-93
Splotch technique, 7, 92–93
Sponges, 19
Sponging technique, 7, 88–89, 100-103

Spray bottles, 19, 105, 108–110
Stain, 7
Stamping technique, 7, 88–89, 94–99
 as drawing aid, 99
Straw blowing technique, 105, 112–113, 117

Surfaces, working with, 36–57
 damp, 44–47
 dry, 38–43
 wet, 48–51

T

Tape, 19
Texturing
 with bruising, 6, 17, 114–115
 drybrush, 42–43, 72
 impressed, 7, 45, 105, 116–121
 with scraping, 7, 17, 19, 36–37, 40
Tools, 8–19
Trees, 54–57, 110–113, 115, 117

V

Value, 7

W

Wash puddle, 7
Washes
 basic, 58–75
 color change in, 70–75
 defined, 7
 drying process of, 59
 flat, 6, 60–65, 69, 74
 graded, 6, 66–69, 74
 layered, 73, 75, 84–85
 optical color change in, 76, 78–79
 stages of, 59
 variegated, 7, 72–73, 75
Water container, 19
Water drops as technique, 50, 73, 105, 108–109
Water for painting, 19
Water, techniques for painting, 83, 115
Wave, glazing for, 83
Wet-on-wet, 7, 49–51, 73, 76
Wood texture, 115